IMAGES
of Ameri

CHICAGO
BEVERLY/MORGAN PARK
NEIGHBORHOOD

D1003577

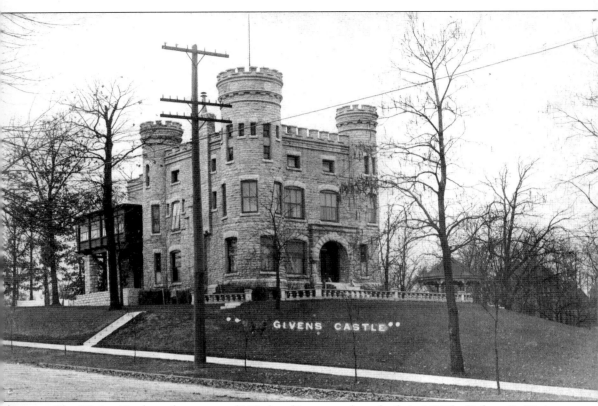

The Givins Castle at the corner of 103rd and Longwood was built in 1886 by Robert C. Givins, a local realtor and part-time writer. He modeled this limestone home after a castle he had seen in County Louth, Ireland and built it for his wife, who reportedly disliked the design. The family sold the home in 1908, and it has been home to the Beverly Unitarian Church since 1942. Beverly Unitarian has used its energy and resources to maintain this historic site while also helping to make the neighborhood "one that celebrates diversity and welcomes people of all good intentions." The Castle has come to symbolize the "Village in the City."

(*cover photo*) The Western Avenue School was located on the north side of Arlington Avenue, now 110th Place and Western. This school was built in 1897 and demolished in 1931 after Clissold Elementary was built just east of this building. This photo shows the eighth grade class of Western Avenue School in 1912. A horse and carriage can be seen on the right in the far background.

IMAGES
of America
CHICAGO'S BEVERLY/MORGAN PARK NEIGHBORHOOD

Joseph C. Oswald
in association with
the Ridge Historical Society

ARCADIA

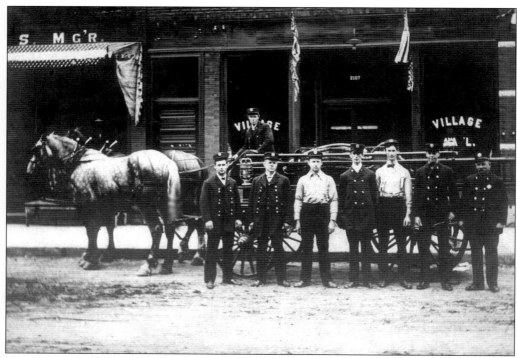

The Morgan Park volunteer firemen are pictured here in front of Village Hall c. 1910. This storefront hall was located at 2107 Morgan Avenue. The two men on the left are Harry Stratton and Charles Stemm. The two men on the right are Robert Nichols and George Myrick. The others are unknown. Charlie Stemm was a policeman, a fireman, a water collector, dogcatcher, truant officer, laborer, etc. for the village and was known for his stern disposition. The fire department did not own horses and used undertaker Charles Lackore's team.

CONTENTS

INTRODUCTION AND ACKNOWLEDGMENTS

Few areas of Chicago continue to stand out as great places to live and raise a family. Unknown to many, one such community on Chicago's far Southwest Side continues to surprise those who come to the area for the first time. Fur traders, railroads, prominent architects, large historic homes, a real Irish castle, the challenges of racial integration, and some of the best schools in the city, are all part of the history of this community. The community possesses unique qualities that instantly set it apart from others. These qualities lie in its history and architecture, excellent schools and geographic location, strong community spirit and civic activism, as well as its unique topography and cultural diversity. Despite these advantages, Beverly/Morgan Park remains one of the best-kept secrets in Chicago and consequently one of its most underrated places to live. In the early 1970s, Beverly boasted some of the highest real estate values in the city. In August 2002, the Chicago Tribune ranked Beverly as the third wealthiest neighborhood in Chicago in terms of median household income. In 1976, the Beverly Area Planning Association (BAPA) and the Ridge Historical Society were instrumental in having the greater part of Beverly/Morgan Park designated the largest urban historic district in the nation on the National Register of Historic Places. The Ridge Historic District roughly covers the area bounded by Prospect Avenue, 89th Street, 115th Street, and Western Avenue and includes three municipally designated historic districts, the Beverly Morgan Park Railroad Stations, the Longwood Drive, and Walter Burley Griffin Place Districts.

Growing up in the area I never realized how special it was until I ventured to other parts of the city and suburbs. I quickly became disappointed in the lack of ingenuity and architectural skill used in designing most of the homes in the suburbs and other parts of the city. This disappointment was no doubt influenced by the architecturally rich housing stock of the Beverly/Morgan Park area in which I was raised. Behind this is still a belief that every man's house is his home and therefore it should be somewhat different than everyone else's. The belief that a person's home, their single largest and most important investment in life, should be an extension of one's personality and creativity is what fuels this ideal. This somewhat idealistic point of view and a seemingly inherent interest in architecture caused me to look more closely at the community in which I lived, and I naturally began to compare it to other areas of the city and suburbs. I had always associated living in a good neighborhood with living in Beverly. The more I looked at and examined the community, however, the more I realized that what was special about the community was not just the homes, but also the circumstances and events around which the community developed as well as the people who have called this community home.

The growing pride I had in where I grew up fueled a desire to tell the story of a great neighborhood. That first story of a great neighborhood started out as a research paper I did

while pursuing a Masters degree in history at DePaul University. With some encouragement and many obstacles and reservations, I turned that research paper into my first book in 2001. Still, by no means complete or all-inclusive, the book you are currently reading is my second attempt to convey my thoughts, feelings, and even biases of a community that has played a tremendous role in the shaping of many of my attitudes and predispositions. Pride in the community and the desire to see it continue to prosper was the driving force behind my first book about the Beverly/Morgan Park neighborhood, and it continues to be the primary motivator in this attempt. My first book focused more on the Beverly locale, which is specifically where I was born and raised. With the help of the local Ridge Historical Society I was able to complete this project, which is hopefully more inclusive in nature.

This book would not have been possible without the cooperation of the Ridge Historical Society. I am especially grateful for the hard work and dedication of Society volunteers Dave Daruszka, Linda Lamberty, Jennifer Kenny, and Sue Delves, who spent hours of personal time sifting through and scanning hundreds of photographs, as well as researching and editing the captions that accompany these images. Their enthusiasm, visionary support, historical knowledge, and desire to preserve, as well as share the history of this great community have made this project possible. The generations of people who have saved, collected, and donated photographs of the community, as well as all of those volunteers at the Ridge Historical Society who over the years have volunteered time caring for historical material, are also owed a debt of thanks. Their efforts have made it possible to add images to history. All of the images in this book are courtesy of the Ridge Historical Society unless otherwise noted. To find out more about the Ridge Historical Society and the important work it performs, please visit their website at: www.ridgehistoricalsociety.org.

I also owe a debt of gratitude to Samantha Gleisten of Arcadia Publishing who went the extra mile to help me to gain support for this project and shepherd me through the publishing process. Had my first book about the Beverly neighborhood not been a success, this book would not have come to pass. Therefore, I also owe a great deal to Debbie, whose patience, understanding, help, and moral support provided the encouragement needed to overcome many obstacles and frustrations encountered during the writing of the first. And last but not least, I dedicate this book to my parents and thank them for the opportunity to grow up in a great house in a great neighborhood, where I was exposed to many of the values and idealistic beliefs I now have.

Feedback on this project is important and always welcome. Though most of my professional background is in education for the Chicago Public Schools, my neighborhood is my passion. Therefore, please visit my website to contact me for feedback, questions, or comments: www.JoeOswald.com.

Joseph Oswald

A Brief History of the Ridge Communities

The Beverly Hills/Morgan Park community is located in the far southwest corner of Chicago. The construction of railroads through the area played a tremendous role in its development, and commuter train service provided by the Chicago Rock Island and Pacific Railroad further accelerated the growth of what would eventually become a "railroad suburb" of Chicago. Before the railroads, the Vincennes Road served as an important trade route linking Chicago with areas to the south and east. The road itself began as an Indian trail that was used by the area's indigenous people to skirt the surrounding swamps. Early travelers through the area marveled

at its beauty, especially the heavily wooded ridge that rose above the surrounding marshes and prairies. This natural formation, which became known as the Blue Island Ridge, was a remnant of the last great glacial age and is the highest point of the surrounding area.

After the forced relocation of the Pottawatomie Indians, John Blackstone purchased considerable land from the United States Government at a cost of $1.25 per acre in the mid-1830s. Englishman Thomas Morgan bought much of Blackstone's land and more around 1844 and established a gentleman's farm and country retreat to which Morgan brought his family. Other early settlers included entrepreneurs who would open taverns to accommodate travelers passing through the area, including farmers bringing produce and livestock to market on the Vincennes Road. Norman Rexford's establishment, the Blue Island House, had taken its name from the ridge itself. Following Morgan's widows death, his heirs sold their holdings to a group of local businessmen and real estate speculators who subdivided this property for residential development. They sought to attract a wealthy, sophisticated clientele and succeeded in creating a fashionable community by the end of the 19th century.

Three distinct areas grew out of what was once remote prairie and marshland. The more urban Washington Heights contained the area's industrial and commercial base, while Beverly Hills and Morgan Park developed into single-family residential communities. The rapid growth of Chicago captured these suburban satellites into its gravity. Annexation to the city threatened to alter their destinies, but these communities continued to prosper and attract wealthy and influential residents well into the 1900s. Building booms after World Wars I and II added a broader economic mix of housing, boosting the population yet maintaining a distinct suburban character. Much of the area's cachet is due to the exceptional and innovative architecture that graces its streets, representing a pantheon of residential styles. This variety and quality has earned large parts of the community landmark recognition on both the national and local levels.

The community has always been a center for educational excellence, artistic and cultural activities, and social advocacy. The area's earliest boosters consciously sought to attract major educational institutions to locate in the area. Throughout the years residents formed numerous theatrical, choral, and cultural organizations in the pursuit of their individual muses. Clubs and societies sprang up to address local and national issues of concern and importance. Churches were built and became the centers of religious and social life in the community. The legacies of that activism are incomparable public and private schools; a vital regional art center; a public gallery of American Impressionist paintings honoring one of its great local artists; and active social, civic, and religious groups that represent a broad spectrum of beliefs and viewpoints.

Economic, business, and racial changes in the 1960s and 1970s threatened the community's immunity to what were once considered exclusively inner-city problems. These issues were met with a concerted effort from community organizations, as well as religious and civic leaders, to ensure the strength of the neighborhood. The "Village in the City," is today a vital and vibrant example of successful integration and community activism. Numerous events held throughout the year bring neighbors and visitors together to celebrate the values and beliefs that make this one of the truly great places to live.

The Ridge Historical Society is pleased to have the opportunity to share a small portion of our photographic collection. While this book could not begin to tell the full story of our history, we hope that the prose author Joe Oswald offers in companion to our images will convey a fascinating glimpse of the people, places, and events that have shaped Beverly Hills and Morgan Park.

Ridge Historical Society

One

THE BLUE ISLAND

The area's distinguishing feature is the hilly topography that places it 30 to 60 feet above the rest of the city and is characterized by an ancient ridge that extends south along Longwood Drive from 91st to 119th Streets. The ridge was a terminal moraine formed between ten and fifteen thousand years ago by a glacial action from the last ice age. The ridge came to be called the Blue Island by soldiers from Fort Dearborn because of the blue haze that seemed to cover the wooded ridge. The ridge created a topographical feature that would distinguish the area from the rest of Chicago's suburbs, and it proved to be an immeasurable factor in the development of the area. Not only did the ridge create a hill in an otherwise level Chicago, but in the future, the ridge proved to be an ideal location for Chicago's elite to build some of the most impressive homes in the Chicagoland area.

The area's original inhabitants were the Potawatomi Indians, who surrendered their land to the United States government in 1833 and were forced to move west. The topography of the ridge provided a convenient location for several Indian trails that helped them to avoid the surrounding marshland, the most famous being the Vincennes Trail. Extending from Fort Dearborn, in what is present day downtown Chicago, it ran southeast as far as Vincennes, Indiana. Nomadic fur traders, such as Joseph Bailly De Messein, were common visitors to the area. Bailly, a French Canadian fur trapper, established a homestead on the Calumet River in 1822. Bailly and his partner Chief Alexander Robinson became agents for John Jacob Astor, founder of the American Fur Trading Company.

The first permanent settler to the Ridge, DeWitt Lane, built a log cabin in 1832 near 103rd and Seeley. Settlers would trickle into the area, and in 1839 John Blackstone bought 9,000 acres of land from the government for $1.25 per acre. In 1844, Thomas Morgan, an English gentleman, arrived and purchased 3,000 acres of Blackstone's land, approximately the area from 91st to 115th Streets, between Vincennes and California Avenues, for $5,450. Morgan raised cattle and sheep on his country estate, Upwoods, and it became a popular hunting spot for his friends and visitors. Stagecoach service eventually linked the Village of Blue Island at the southern end of the ridge to the city. A ravine on the eastern edge of the southern end of the ridge was notoriously known as Horse Thief Hollow, a place where brigands hid in the thick cover afforded by the lush foliage and trees. This pastoral setting would quickly be supplanted by the clamor of the steam engine that would bring a new way of life to the area.

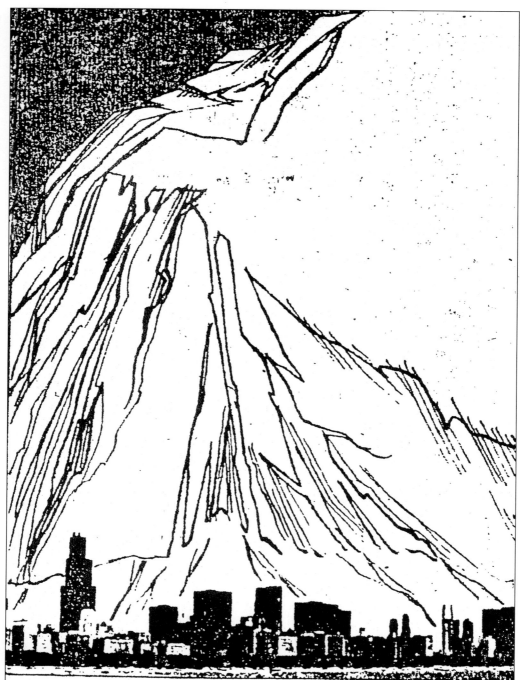

The most recent glacier to visit Chicago, the Wisconsinian of 18,000 years ago, would have towered two miles above the city streets.

12,000 years ago, Chicago ran just swimmingly

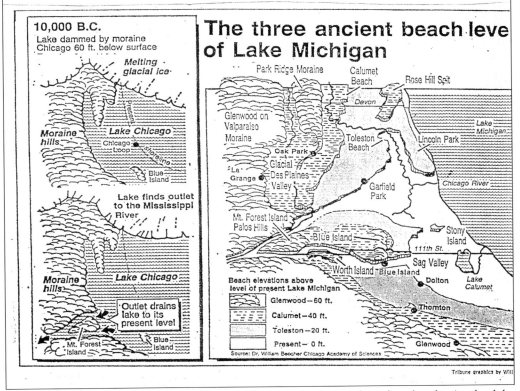

10,000 B.C.
Lake dammed by moraine
Chicago 60 ft. below surface

Melting
glacial ice

Moraine hills

Lake Chicago

Chicago Loop

present shoreline

Blue Island

Lake finds outlet to the Mississippi River

Moraine hills

Lake Chicago

Outlet drains lake to its present level

Mt. Forest Island

Blue Island

The three ancient beach levels of Lake Michigan

Park Ridge Moraine

Calumet Beach

Rose Hill Spit

Devon

Glenwood on Valparaiso Moraine

Oak Park

Toleston Beach

Lincoln Park

Lake Michigan

La Grange

Glacial Des Plaines Valley

Garfield Park

Chicago River

Mt. Forest Island Palos Hills

Blue Island

Stony Island

111th St.

Sag Valley

Worth Island Blue Island

Dolton

Lake Calumet

Beach elevations above level of present Lake Michigan

Glenwood—60 ft.
Calumet—40 ft.
Toleston—20 ft.
Present—0 ft.

Thornton

Glenwood

Source: Dr. William Beecher Chicago Academy of Sciences

Tribune graphics by Will

The various stages of the draining of Lake Chicago are depicted in this sketch. As the lake continued to drain, the geological formation known as the Blue Island became more pronounced. Lake Chicago would continue to shrink and evolve into Lake Michigan. Lake Michigan's original shoreline was located at the Blue Island Ridge. It eventually receded to the Michigan Avenue ridge in Roseland (103rd and Michigan), and the water finally receded to its present location (please note that much of Chicago's lakefront is landfill created from debris of the Great Chicago Fire. Roughly, Michigan Avenue to the current shoreline is landfill). (Copyrighted 2/24/80, Chicago Tribune Company. All rights reserved. Used with permission.)

(*opposite*) The Wisconsinian ice glacier was two miles thick and formed during the last Ice Age. As the glacier receded around ten to fifteen thousand years ago it produced a large body of water called Lake Chicago. The receding glacier produced the ridge that runs above present-day Longwood Drive. (Copyrighted 2/24/80, Chicago Tribune Company. All rights reserved. Used with permission.)

11

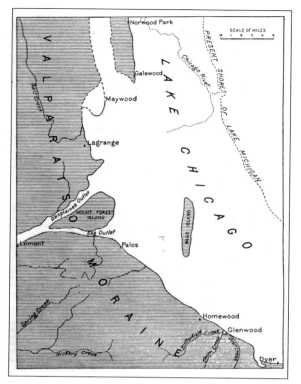

The rising and falling water levels caused by glacial action resulted in different stages of draining. This view of Lake Chicago and the Blue Island formation shows them during the 60-foot Glenwood stage. During the Glenwood stage the island rose ten to thirty-five feet above the surrounding waters. The erosion caused by the constant wave action against the shore of the island during the Glenwood stage created a terrace and cliff. The flowing of water at the southern edge of the ridge left a deposit of gravel and sand on which the village of Blue Island was built.

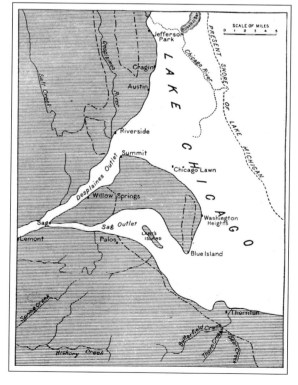

The emerging Blue Island can be seen here during the 40-foot Calumet stage. The water had outlets through the Calumet Sag-Des Plaines route as well as the Great Lakes-St. Lawrence outlet. The Valparaiso terminal moraine, which created the ridge, runs through the modern-day southwestern suburbs of Chicago, which included Palos Hills, Worth, Lemont, and Homewood. Washington Heights and other future Chicago neighborhoods are noted on this map.

12

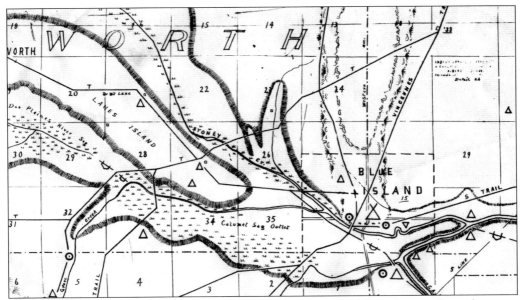

This sketch of the Blue Island area includes the Vincennes Road, Indian trails, and various geographic features. The Great Lakes outlet of water often became obstructed by ice gorges, which caused a variance in water levels. The 30-foot Tolleston stage marked the end of the partial re-submergence of the plain.

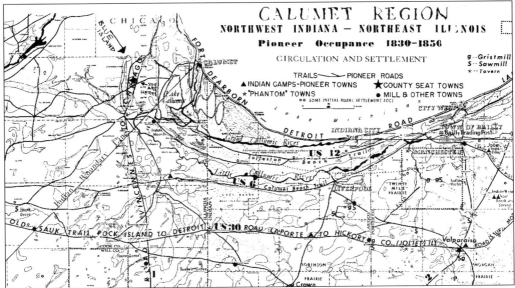

The Calumet Region of northwest Indiana and northeast Illinois is shown in this map from the years 1830-1850 and identifies a number of early settlements and pioneer roads. These include the Vincennes Road, which ran from Fort Dearborn to Vincennes, Indiana, passing through the Ridge. The Vincennes trail eventually evolved into a more accessible road after it was moved to make way for railroad tracks in 1852. The Vincennes trail proved to be an important factor in the early development of the area as various businesses sprang up along the widely-used road to accommodate travelers and take advantage of the proximity to the railroad.

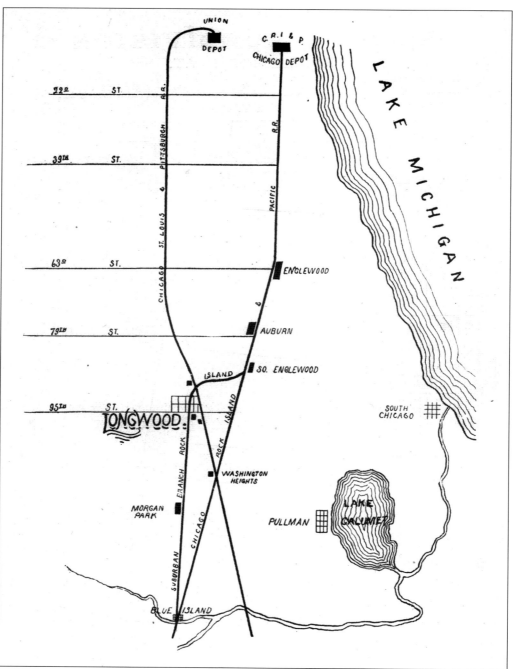

Rail lines ran north from Morgan Park and Washington Heights in 1889 to downtown train stations. This map highlights the convenient transportation opportunities produce by the developers of the Longwood subdivision near 95th Street via the Rock Island and Panhandle Railroads. Growth of the Calumet region, including Pullman, South Chicago, and Blue Island, was spurred in 1869 when the federal government appropriated money for the improvement of Calumet Harbor.

Two

THE RAILROADS
ARRIVE

In 1864, the Chicago & Great Eastern Railroad began construction of a line from Chicago to Logansport, Indiana. The primary purpose of this line was the shipment of livestock to the newly opened Union Stock Yards, a direct outgrowth of the increased demand for processed meat for troops fighting the Civil War. The line, later known as the Panhandle, passed through the northern edge of the estate of Thomas Morgan. A station, Upwood, was established as a concession from the railroad for use of his land for its right of way. Further to the southeast the Panhandle crossed the tracks of the Chicago, Rock Island and Pacific Railroad at Vincennes and Tracy Avenues (103rd Street). A small settlement of railroad workers formed at this railroad junction, which was known as "The Crossing." This area would eventually grow into the Village of Washington Heights and serve as the genesis for further development of the area. The Rock Island laid its tracks to Joliet through the area in 1852, draining the surrounding swampland, and in the process, attracting subsistence farmers to the newly opened acreage. While the Panhandle provided an "accommodation train" for the convenience of area residents, the Rock Island saw no need to stop in the sparsely populated area before its trains reached Blue Island. The potential for residential development, and the traffic it would generate, would change that decision.

Between 1867 and 1869, Thomas Morgan's land was divided among his heirs. They eventually sold their holdings to Frederick H. Winston, who helped form the Blue Island Land and Building Company in 1869 along with George C. Walker, John F. Tracy, T.S. Dobbins, J.B. Lyon, C.W. Weston, and Mr. Millerton. The company paid $100,000 for 1,500 acres of Morgan's land. All of this land was originally platted as the Washington Heights subdivision in 1869. However, the area between 107th and 119th Streets was separated and named Morgan Park, after Thomas Morgan. Between 1869 and 1870, Englishman Thomas F. Nichols designed the winding streets and roundabouts found in Morgan Park.

The Blue Island Land and Building Company included executives of the Rock Island Railroad and Chicago Union Stockyards on its Board of Directors. The Rock Island constructed the Washington Heights Branch line west of the main line from "Dummy Junction" (97th Street) to about 100th and Wood. This line then turned south and paralleled the ridge, where it reconnected with the main line at Blue Island. This branch line would prove to be critical in the development of the community. Many of the early settlers were English, but many of the rail workers were German, and they settled near 103rd Street (Tracy Avenue).

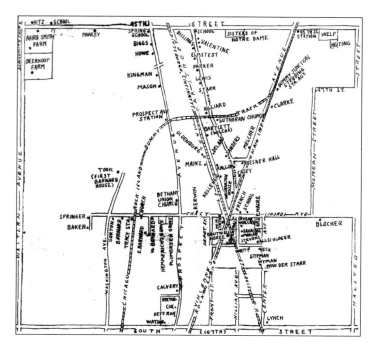

The original location of the Rock Island's Washington Heights Branch line until 1889 crossed 99th Street and Washington Avenue. The "dummy" line served the Prospect station at 99th Street, which was abandoned in 1890 when the line was extended north to 87th Street. The line ran down 99th Street before joining the main line at Vincennes. Though farms can still be seen on this map near 95th and Western, the subdivision of land and subsequent home construction were rapidly replacing farming as the primary economic activity.

The Rock Island Railroad was chartered in 1851. Construction was completed to Joliet in 1852. This 1909 map illustrates the confluence of railroads that entered the city through the south side. Englewood was an important rail junction and quickly grew from a quiet village into a bustling hub. Industry located along the rail lines, with factories, stores, and housing replacing the bucolic countryside. As these areas became more urbanized many well-to-do residents sought to flee the encroaching city by moving to the country. The Ridge communities benefited from this growing exodus of families seeking to escape the dangers of city life, as new residents were attracted by its amenities. (Map image from the collection of Jennifer Kenny. Used with permission.

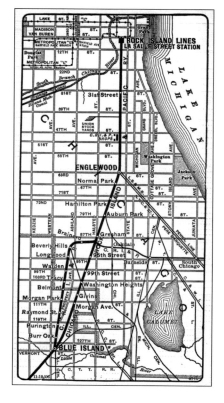

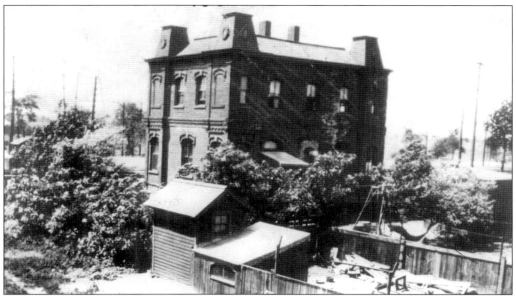

The Rock Island's Longwood Manor station was located on the main line at 95th Street and Vincennes, built in 1876 and demolished in 1937. In 1911, the O'Connor family came to reside in the station, and was the boyhood home of Charles O'Connor, who would later become an engineer for the railroad. The station was provided as a residence to the family when Charles' father was killed in a railroad accident. In the days before workman's compensation the railroads often provided such perks to injured employees and surviving family members, who continued to work and provide for their families.

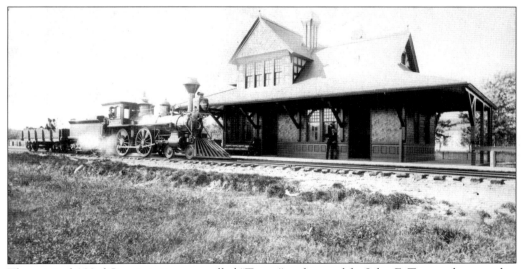

The original 103rd Street station was called "Tracy," and named for John F. Tracy, who served as president of the Rock Island Railroad. Each station on the branch line was designed in a unique style that reflected the pride of the community residents who often contributed to the construction costs. The stations contained living quarters for a commission station agent who was provided with free lodging by the railroad. The agent made his living on commissions from selling tickets and providing services such as Western Union telegraphs and Railroad Express shipping.

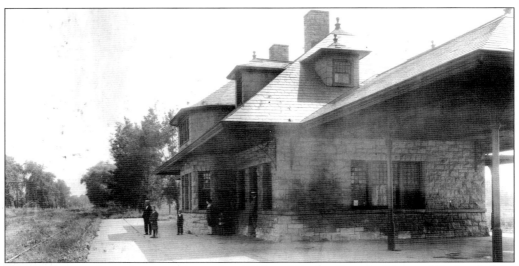

This 1920s view shows the station located at 115th and Rockwell on the Terminal Railroad of the Baltimore and Ohio. The B&O, as well as the Grand Trunk & Western provided service to the cemeteries that sprang up on the western border of the Ridge communities. This station served Mount Hope Cemetery. In the days before automobiles were common, trains were a primary means of transporting mourners and visitors to these remote cemeteries, which were designed much like parks. A trip to one was an all-day affair often accompanied by a picnic lunch. The station, which had been converted to a private residence, was destroyed by fire in the 1960s.

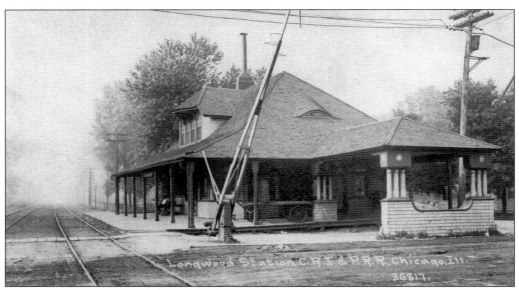

The Longwood Station of the Rock Island Railroad is seen in the undated photograph. The shingle-style station features an ornate porte-cochere for the protection of passengers alighting from their carriages. Later, 95th Street would develop into an important business district that attracted shoppers from around the city. Its prominence as a retail strip would be eclipsed in 1952 with the construction of Evergreen Plaza, one of the nation's first shopping malls. The Plaza marked the beginning of a national trend that would help to destroy many small neighborhood business districts.

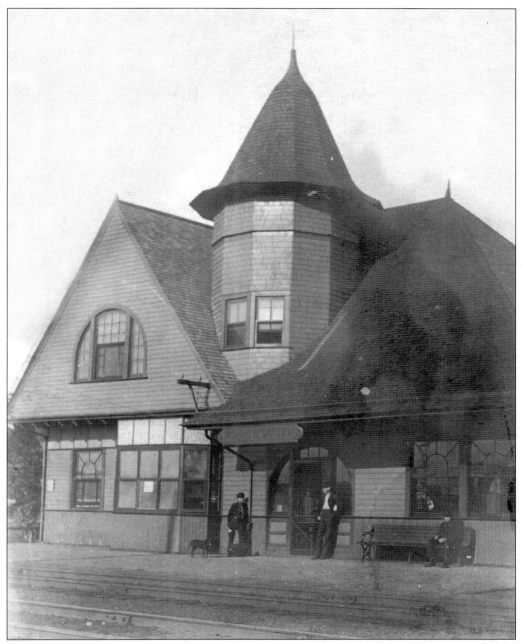

The 91st Street Station is located at the far north end of Beverly and fronted by a small park, helping to give the overall impression of a small-town depot. When the Rock Island fell on hard financial times they allowed this and the other neighborhood stations to deteriorate. Train service began to suffer as well. This station was slated for demolition, but was saved at the eleventh hour by a concerted community effort to restore the station. It is now one of six stations in the community that comprise a unique city landmark district. Owned by Metra, the public agency responsible for commuter rail service in the metropolitan region, it is scheduled for restoration in the near future.

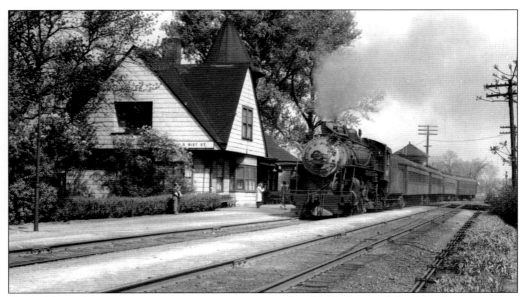

A southbound commuter train prepares to stop in this 1946 photo of the 91st Street station. The train has just crossed the junction with the Pennsylvania Railroad, successor to the Panhandle. This busy crossing point handled freight and passenger trains for the Pennsylvania and Baltimore & Ohio as well as the Rock Island commuter trains. The tower, seen just behind the train, housed the operator who controlled the switches and signals at this crossing point. This station is near the site of Thomas Morgan's Upwood estate.

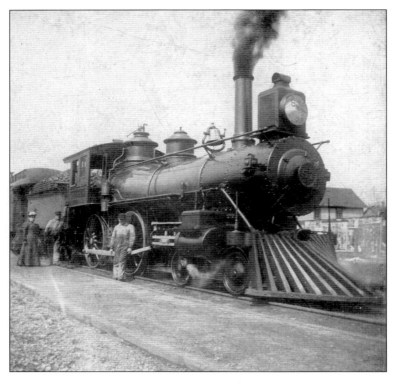

This view from the late-1800s shows a Panhandle passenger train, possibly at the joint station with the Rock Island at 103rd Street in Washington Heights. The odd Panhandle moniker originated from a portion of the line that passed through the panhandle region of West Virginia. The railroad eventually became part of the Pennsylvania Railroad and later the Penn Central, which subsequently abandoned the right-of-way. It is used today as an urban bicycle trail.

The term "Dummy Line" has unusual origins. The first train service provided by the Panhandle used what was known as a dummy locomotive, a combination passenger car and locomotive, that was often used on lightly traveled lines before the turn of the century. The Rock Island utilized a small locomotive as well, known as a Forney-type that combined the coal tender as part of the locomotive. Somehow the dummy appellation crossed railroads, probably because of the diminutive locomotives, and for many years local residents knew the branch line as the Dummy Line. This photo shows a Forney-type locomotive near 99th Street in the early 1900s.

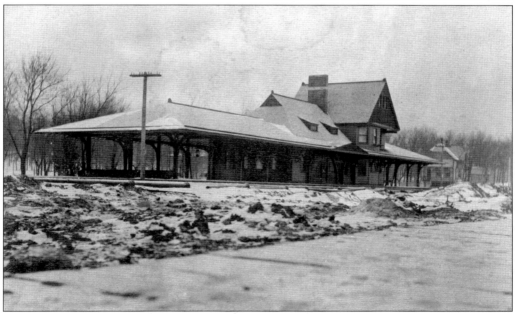

The Morgan Park station at 111th Street is an impressive building designed by architect John T. Long. The original station on this site was moved south and converted to a private residence that still stands today. This photograph dates from around its construction in 1889 and shows the east side of the handsome Romanesque depot. Local businessmen and residents contributed $2,720 of the $5,220 construction costs. The station was recently restored at a cost of over one million dollars and is a designated city landmark.

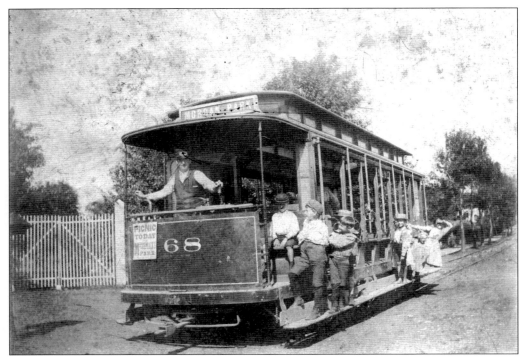

The children frolicking on this open-sided streetcar might have been on their way to the picnic advertised on the sign on the front of the car. The Chicago and Interurban Traction Company ran from 63rd Street to Kankakee with a branch on 111th to the Mount Greenwood Cemetery.

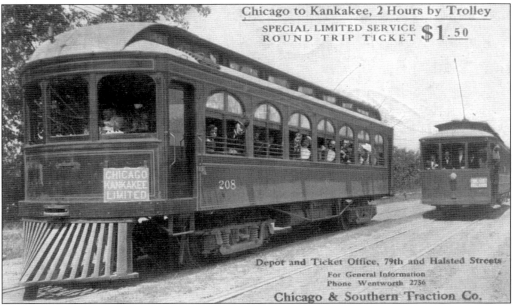

Chicago to Kankakee, 2 Hours by Trolley

SPECIAL LIMITED SERVICE
ROUND TRIP TICKET $1.50

Depot and Ticket Office, 79th and Halsted Streets
For General Information
Phone Wentworth 2756

Chicago & Southern Traction Co.

A heavy weight interurban car passes a trolley car in this advertising postcard for the Chicago and Southern Traction Company, predecessor to the C &IT. Service was abandoned on April 23, 1927, due to low passenger revenue and increasing competition from private automobiles.

Three

GROWTH AND
CHANGE

The community of Washington Heights was incorporated as a village in 1874. Much of the early development would follow a westward path along Tracy Avenue. A community called Tracy would form around the train stop on the branch line, although the area was still considered part of Washington Heights for many years. Stations on the branch were established at Prospect (99th), Tracy (103rd), Belmont (107th), and Morgan Park (111th). The branch line was expanded northward in 1889 from 99th Street through what is present day Beverly Hills. New stations were built at Raymond (115th), Walden (99th), Longwood (95th), and Beverly (91st). The original stations at 103rd, 107th, and 111th were replaced with more impressive structures. Large numbers of people moved south to Washington Heights and were able to commute to jobs in the city. The majority of these people were white Anglo-Saxon Protestants who belonged to Chicago's economic elite. Protestant institutions began to appear, including Bethany Union Church, which was organized in 1872 and built its own church in 1874.

After the Great Chicago Fire of 1871, Morgan Park was marketed as a country retreat for the well to do. The Blue Island Land and Building Company sought to create an enclave for the middle to upper-class clientele, and impressive mansions were built along the Ridge and surrounding streets. Originally, lots sold for $4 to $20 per frontage foot, the latter amount for lots 400 feet in depth. Incorporated in 1882, it differed greatly from the more urban atmosphere of the Heights.

According to local lore, the name Beverly was reportedly suggested by Alice Helm French, wife of William M.R. French, the first director of Chicago's Art Institute, after her childhood home in Massachusetts. She suggested "Beverly" as the name for the 91st Street train station, which was built in 1889. This is still a matter of speculation and has not been confirmed. "Hills" was added by the railroad at a later time. A section of Beverly north of 95th Street was annexed to Chicago in 1890. A month later the area east of Western Avenue between 95th and 107th Streets was annexed as part of the village of Washington Heights. The last piece of land that comprises Beverly, south of 99th Street between Western and California Avenues, was annexed to the city in 1914 with Morgan Park. In 1914, the residents requested that the telephone company unify all three of its exchanges into one Beverly exchange. In 1917, local businessmen petitioned the Rock Island to change the name of all the suburban stations from 91st to 103rd Streets to Beverly Hills, thus providing the area with its own identity. It has been rumored that Beverly Hills, California was named after this Chicago neighborhood. The California suburb actually was developed by the Rodeo Land and Water Company in 1906 and incorporated as a town in 1907. The company was formed by Burton E. Green, who was also from Massachusetts. The towns of Beverly and Beverly Farms are about eight miles northeast of Boston, on the coast of Massachusetts Bay.

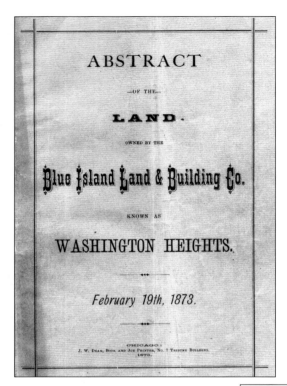

George C. Walker served as president of the Blue Island Land and Building Company, which was formed in 1869. The company subdivided much of Thomas Morgan's land and sold it to various builders and developers, including Frank and Charles Silva, Frederick Winston, and Willis Hitt. Improvements were made to the area, including sewers, landscaping, and paved streets. By 1900, Morgan Park had become an exclusive residential community and home to executives from the Board of Trade, Union Stock Yards, the Chicago Bridge and Iron Works, and the Rock Island Railroad. This is the cover for the record of land transactions of the Blue Island Land and Building Company.

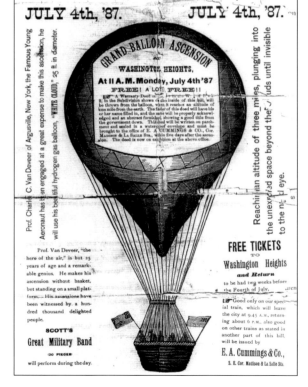

Real estate developers engaged in clever sales techniques, such as land auctions and picnics, to entice potential buyers to the area. This advertisement from July 1887 promotes residential lots in Washington Heights. Both the Panhandle and Rock Island provided free excursion trains to handle the crowds that attended these events. Aside from entertainment provided by a military band, this event featured a balloon ascent where a deed to a parcel of land was dropped to the crowd gathered below. The finder could then redeem the deed for their property.

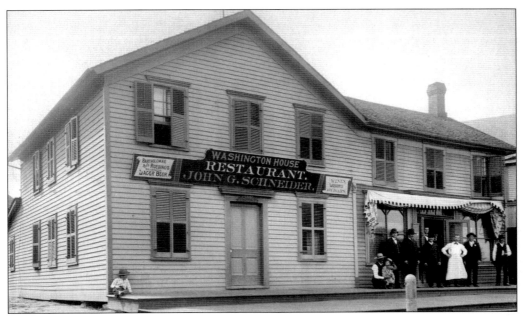

John G. Schneider's Washington House Restaurant was one of the earliest public houses in Washington Heights. Some of the earliest establishments in the area were taverns that served travelers on the Old Vincennes Road. Schneider's was located directly across from the Chicago Bridge and Iron Works and went through a variety of transformations over the years. It served as a hotel during the Columbian Exposition as well as a gathering place for workers and local families.

The year 1893 saw many travelers from around the world come to Chicago to attend the Columbian Exposition World Fair. The demand for housing for this event was an opportunity for entrepreneurs of every stripe. Schneider's proximity to the Washington Heights railroad station would have been a distinct advantage in attracting travelers headed to the fair.

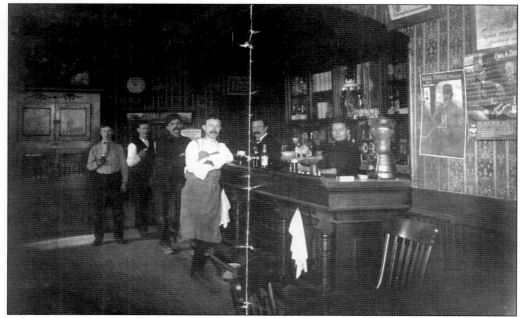

This interior photograph of Schneider's shows the barroom, which would have been limited to men only with the exception of the owner's wife. Elsewhere in the tavern would be a larger room to accommodate families and larger groups, where food would be served. Women and children were not normally allowed in the bar, unless the children were sent to pick up a pail of beer for dad.

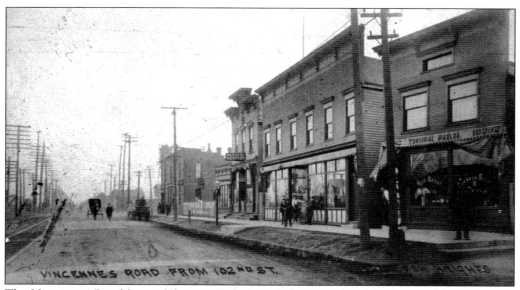

The Vincennes Road began life as an Indian trail that ran along the top of the ridge. With the construction of the Rock Island Railroad most of the original trail was abandoned and the new route parallels the train tracks. The area surrounding the Washington Heights train station developed into a bustling business district. This view looks south from 102nd Street along Vincennes Road. The third building from the right would eventually become Herman Baer's Dry Goods Store.

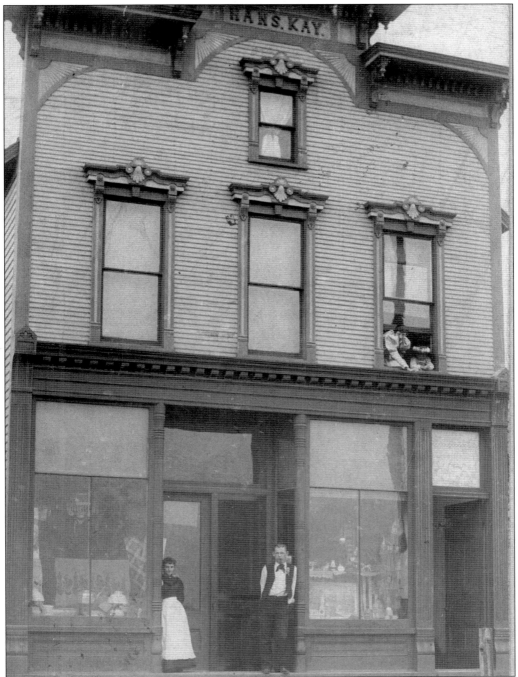

Herman Baer's Dry Goods Store was located at 10236 S. Vincennes in Washington Heights. The "Little Store Doing a Big Business" opened in 1887 and was strategically located on a commercial strip near the railroad. For over 70 years, neighborhood residents shopped at Baer's. The general store sold everything from derby hats to cough drops. Arthur Baer would follow in his father's footsteps and build the business into a store that is still fondly remembered by long-time residents.

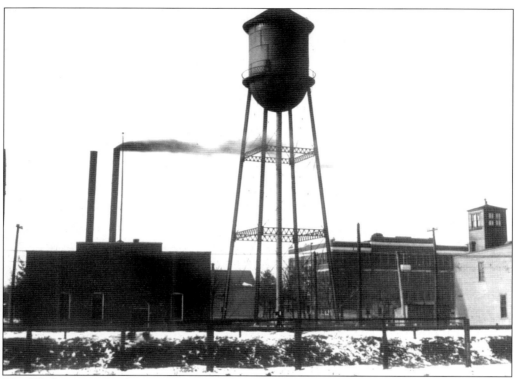

The Washington Heights water tower and pumping plant was located on 104th and Charles. The original Barnard Elementary School, built in 1893 and destroyed by fire in 1940, can be seen in the background. On the right foreground is the old firehouse at the corner of 104th and Vincennes. The water tower was a product of the Chicago Bridge and Iron Works located across the Rock Island tracks from the water works. The site is now a fueling station for city vehicles.

Horace Horton's Chicago Bridge and Iron Works was located at 105th and Vincennes. The company relocated here in 1889 and attracted many people to the area who settled in the surrounding community. The company began as a builder of iron and steel bridges, but was best known for producing water tanks for municipalities and industry. They were an innovator in the design of these structures and specialized in novelty tanks designed to advertise a manufacturer's product. The company also produced landing craft during WWII.

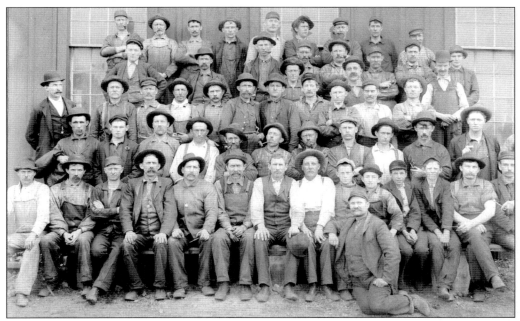

Many of the workers at the Chicago Bridge and Iron Works were of German heritage, and Washington Heights was home to a large Germanic community. The young boys seated in the front row are an interesting aspect of the photograph.

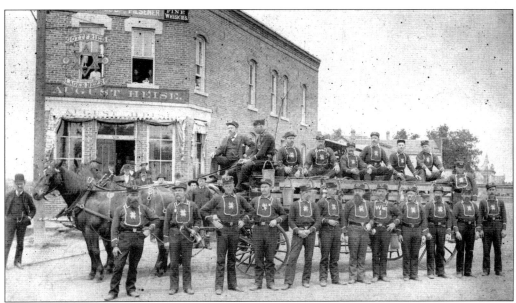

This 1887 photograph shows the Washington Heights Village Volunteer Fire Department standing on Vincennes Avenue at the intersection of Beverly Avenue. The triangular building in the background later became the location of the popular Beverly House Restaurant. The signage on the building shows the Germanic influence along the Vincennes Road. The building was torn down several years ago.

The old Washington Heights firehouse was located at the southwest corner of 104th and Vincennes. The station, built in 1890 or 1891, was home to Hook and Ladder Company No. 24. This station was demolished in 1926 to make way for a new firehouse on the same site. The small cupola at the rear of the building was where canvas fire hoses would be hung to dry.

Looking west from the Rock Island suburban tracks on 103rd Street, one can see the home of Alice Barnard in the foreground, which would later become the Beverly Business College. The house, fronting the peony farm of the Barnard Seed Company, would be demolished in the 1950s and replaced by a grocery store. Givins Castle, seen in the background, was built by developer Robert Givins and still serves as a symbolic landmark of the community.

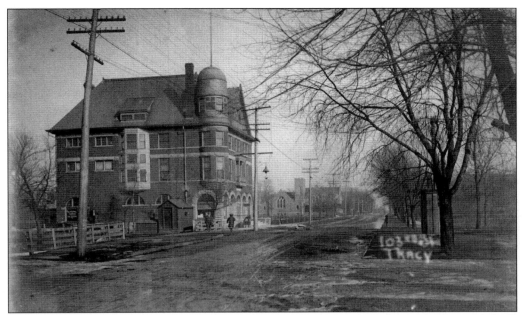

Tracy Hall can be seen in this photo looking east on Tracy Avenue (103rd Street). The newly built Bethany Union Church, located on Tracy and Wood Streets, is seen in the background. Tracy Hall served as the Masonic Lodge and a local meeting place. The building also contained stores and offices. The small wooden shed in the foreground is a shanty for the railroad crossing guard who was responsible for stopping street traffic for approaching trains.

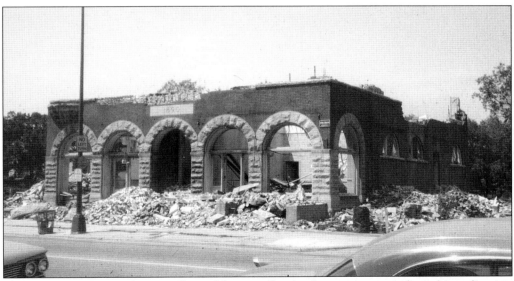

Like so many other architecturally and historically significant structures throughout the city, Tracy Hall could not escape the wrecking ball and was thoughtlessly demolished in 1963. The lot it occupied directly east of the Rock Island tracks remains vacant. The demolition was symbolic of destruction that razed some of the most architecturally impressive buildings throughout the city in the name of profit and progress. These losses have been incalculable to the city and its neighborhoods, and yet the destruction continues. This photo was taken May 26, 1963.

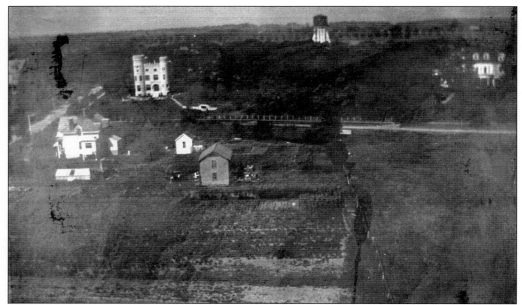

A hot air balloon took this aerial photograph of 103rd and Washington (Longwood) between 1888 and 1890. Balloons were used to promote land sales in the area. This gimmick was indicative of the promotional techniques used by developers of the Ridge. Notice the Barnard House in the left foreground, the Givins Castle rising up on the ridge behind it, and Horace Horton's home at 10200 S. Longwood on the far right. The water tower in the background was located near 102nd between Seely and Hoyne and was serviced by a small pumping station.

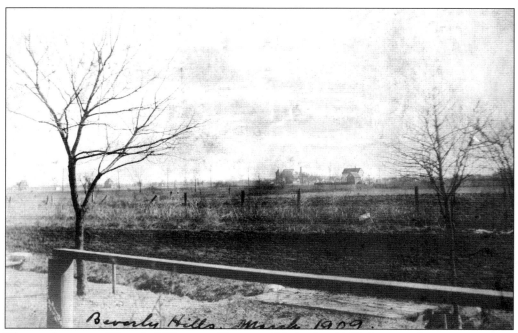

The rural nature of Beverly Hills was still perceptible in this 1909 photograph.

An old street map of Morgan Park shows the winding streets of the village as well as the former names of streets that changed with annexation. Years ago, 111th Street was known as Morgan Avenue, Hoyne was known as Armida, and present-day Longwood Drive was known as Prospect Avenue, south of 111th, and Washington north of 111th Street. Among other streets not pictured on this map, 103rd Street was known as Tracy and 95th Street was known as Spring. Many street numbers also changed with annexation.

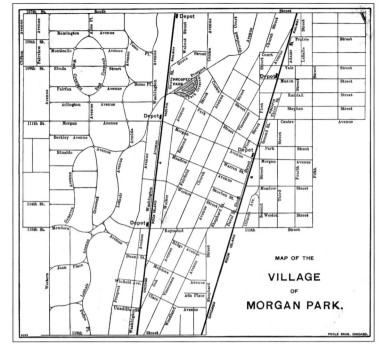

MAP OF THE

VILLAGE

OF

MORGAN PARK.

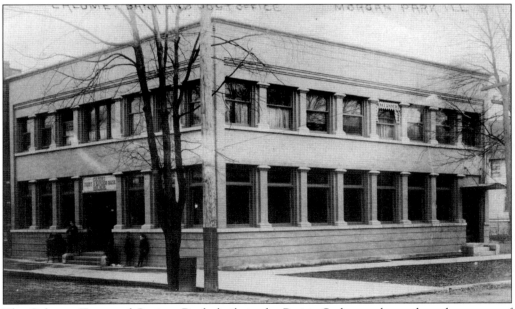

The Calumet Trust and Savings Bank, built in the Prairie Style, was located on the corner of Morgan and Prospect Avenues (111th and Longwood). Community banks encouraged residents to create savings by developing thrifty habits. These banks would invest those savings back into the community in the form of mortgages and business loans, thus strengthening the economic base. Calumet Trust, like countless other small financial institutions, did not survive the Stock Market Crash of 1929. The building did survive and was recently restored by a local development group. It was designed by H.H. Waterman.

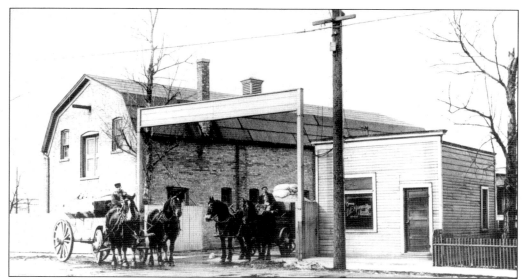

D.F. Marquardt's coal yard, seen here in about 1890, was located at 1040 W. 95th Street, just east of the Rock Island main line at Vincennes Avenue. Coal yards were always found next to railroad lines as they provided the only efficient means of bulk delivery of this important commodity. People of a certain generation can still remember having to tend the coal furnace in the home's basement, and the arduous task of cleaning out the grates of ash and "clinkers." By 1975, it had become the Lang and Son Coal and Ice Company.

John D. Barnes Drug store was located in the Miller Block building, at the corner of Morgan (Monterey) and Commercial (Hale) Avenues just east of the Rock Island tracks. The local apothecary would also contain a cigar store and soda fountain. Many young men would find their first employment experience working the soda fountain or delivering goods to local residents for the pharmacist.

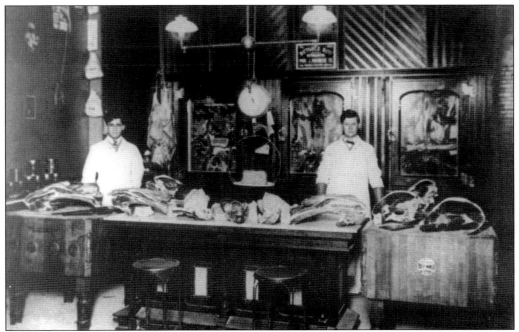

The Kiskaddon and Burke Meat Market was located in the Cormack Block Building at what is now 1949 W. Monterey. Harry Stratton, considered the best butcher in Morgan Park, is pictured on the right. Harry was also the chief of the volunteer fire department and would often answer the call of the fire whistle still clad in his apron. This photo was taken about 1910.

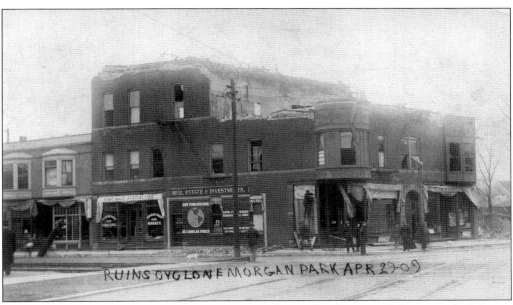

RUINS CYCLONE MORGAN PARK APR 29-09

On Thursday April 29, 1909 a funnel cloud dropped from the sky to wreak havoc in the Morgan Park business district. The tornado extensively damaged a number of businesses and homes, but there were only minor injuries and miraculously no loss of life. This photo shows the twister's devastating effects on the Miller Block.

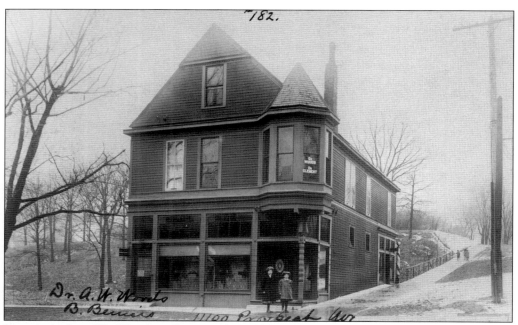

Doctor Arthur W. Wood's office was located in this building at the corner of Prospect (Longwood) and Morgan (111th) Avenues. He would later move his office to his home on Prospect Avenue where he lived until his death in 1964. This building was later replaced by a drug store and parking lot.

Frank and Charles Silva were more than real estate developers. They were community leaders who bestowed this architectural confection known as Silva Hall. The building was the social center for the village where events included memorable dances, concerts, and lectures. Village leaders took pride in the rich cultural life afforded its residents and used this fact in promoting the area as the place for the "right" people. Silva Hall served the community from its construction in 1891 to its destruction by fire in 1907.

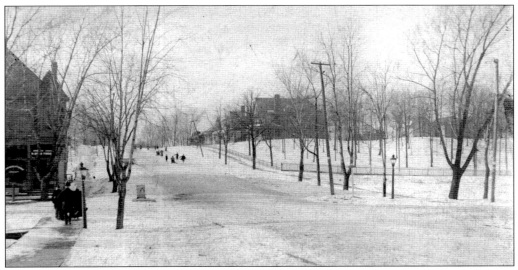

This view of Morgan Avenue (111th Street) looking west as it rises up the ridge illustrates a favorite winter pastime of local children—sledding on the hill where the ultimate goal was to reach the railroad tracks beyond the bottom. This sport would take a tragic turn when a child was killed by a train that struck him as he reached the tracks. Gaslights date this photograph to the late 1880s. The lights were ignited with a torch by a lamplighter. Electric streetlights did not come to Morgan Park until 1910.

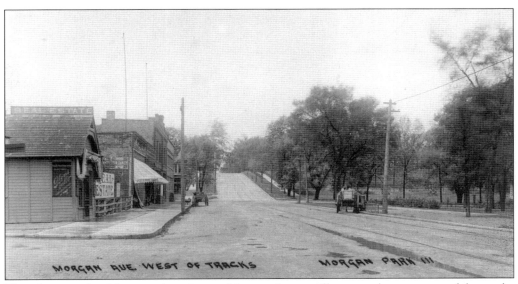

This photograph of the same location on Morgan Avenue illustrates the steepness of the grade. The trolley tracks in the street belong to the Chicago and Interurban Traction Company whose trains ran from the 63rd Street Elevated Station to Kankakee. A spur line ran west on Morgan to Mt. Greenwood Cemetery, and a specially designed funeral car was available for corteges. The trolleys were first powered by storage batteries that were changed and recharged near the 63rd Street terminal. The steep grade required the construction of an underground counterweight system to help pull the cars up the hill. The weights and mechanism might still be buried under the street.

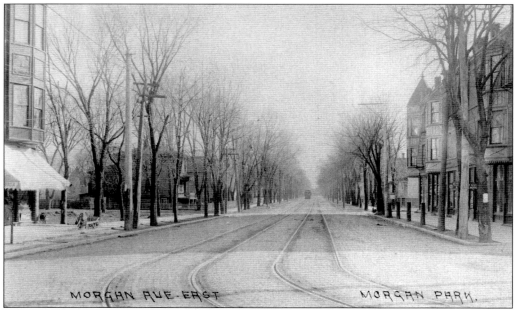

Morgan Avenue (Monterey), looking east with a westbound streetcar approaching in the distance, was still a mix of business and residential uses when this photograph was taken. The street would eventually become a predominantly commercial strip that would subsequently fall on hard times in the 1960s. Concerned citizens attempted to save the district with a "Victorian Village" themed rehab concept, but it was unsuccessful in staving off the wrecking ball. Urban renewal would lay waste to the area that was once the traditional downtown Morgan Park.

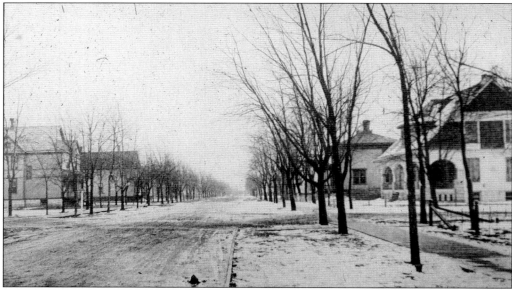

This 1892 photograph of Morgan Avenue predates the arrival of streetcars, and shows the early stages of development in the Village. The wooden sidewalks and unpaved streets speak of a bygone era that would quickly pass as development swept the area. The home on the right of this photograph is the only building still standing, and is presently used by the Catholic Youth Ministry.

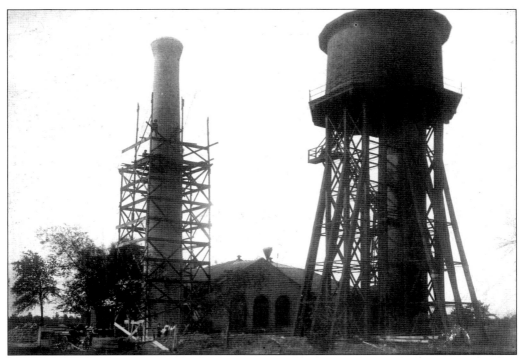

The Village of Morgan Park water works was built in 1878. Early water for the Ridge was supplied by underground artesian wells, brought to the surface using pumps, and then stored in water tanks like this one. One well was 1,400 feet deep while another was an impressive 12,000 feet deep. This facility was located on an island at the intersection of 115th at Bell and Lothair. This wooden tank collapsed and was replaced by a steel tower in about 1905 and eventually torn down in 1915, not long after annexation to the city. The site is now a small park. This photograph was taken in 1890.

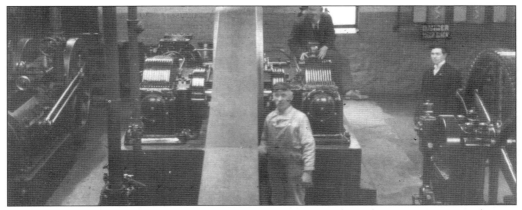

The inside of the 115th Street water pumping station must have been a very noisy place to work. Electricity for the pumps was generated by a 75-horsepower engine and dynamo. The quality of the artesian water was a point of pride for village leaders and a bone of contention for those citizens who were opposed to annexation to the city. The "anti-anns," as they were called, often cited the foul condition of the Lake Michigan water Chicagoans drank as one reason not to give up the village's independence.

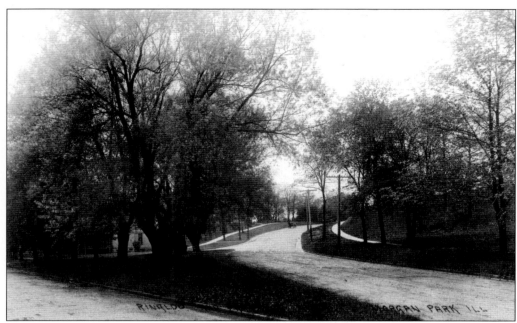

Rinaldo Avenue sweeps up the ridge in this photograph taken from Prospect Avenue. Early in the village's development, the hilltop lots were not always considered as desirable as those on lower ground, as horses would be forced to struggle up the steep grades. This scene still appears much the same today.

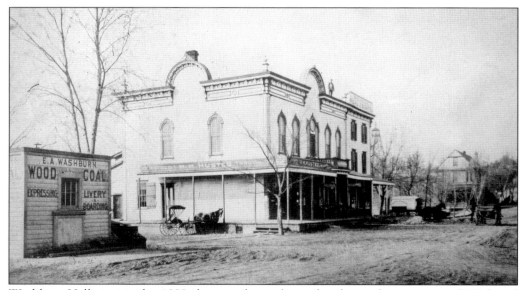

Washburn Hall, seen in this 1889 photograph, was located at the southwest corner of 111th and Hale, just south of the Morgan Park train station. Built in 1872, it served as a focal point for the social life of early Morgan Park. The building served as Village Hall from 1882 until its destruction by fire in the late 1890s. The building was used for public meetings and several churches held their first services here. The first floor contained stores and a post office. William W. Washburn owned the building and was Morgan Park's first postmaster.

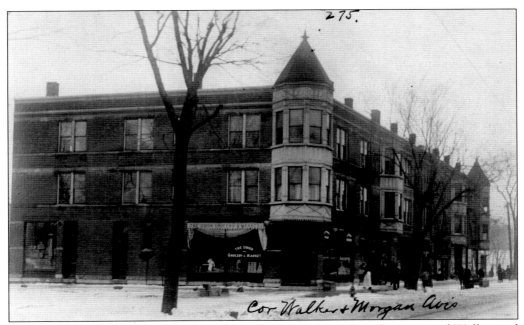

The Cormack Block of apartments and storefronts was located at the corner of Walker and Morgan directly across from the Miller Block. Built in 1890, it marks the increasing urbanization of the sleepy Village of Morgan Park. The building was demolished in 1938.

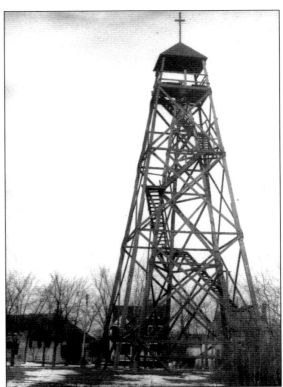

The United States Coast Survey Tower, built in 1871, was located at Morgan and Armida Avenues (now 111th and Hoyne). The federal government used this structure for surveying Lake Michigan. The wooden tower was used as a platform for a series of sweeping photographs of the burgeoning village in the 1880s. It was a favorite climbing spot for adventurous boys until its deterioration caused the Village government to ban the practice. It was demolished in 1902 and the site is now occupied by an apartment building.

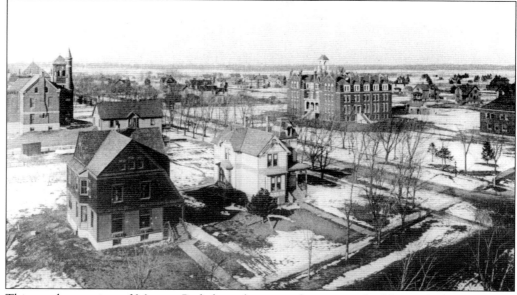

This northwest view of Morgan Park from the tower shows many buildings of a bye-gone era. Blake Hall, part of the Morgan Park Military Academy, is the building on the left behind the homes in the foreground. The Baptist Theological Seminary is to the right. The Village sought to bring the University of Chicago to the area but lost the prize to Hyde Park. When the Seminary relocated to the new university, Seminary Hall became part of the Academy and was renamed Morgan Hall.

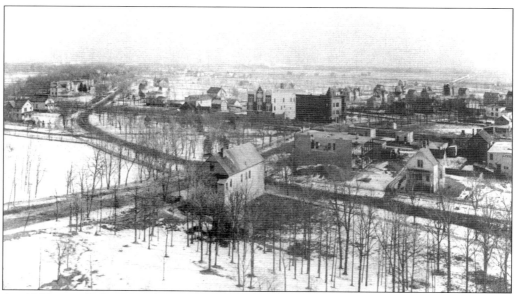

An 1892 view looking northeast of Morgan Park from the observation tower illustrates how development clustered near the railroad station. The office of Dr. Woods can be seen in the foreground. Charles Lackore's livery stable can be seen on the far right. Silva Hall and the Miller Block are the tallest buildings in the center of the photograph. Prospect Avenue curves to the left and was the location of the homes of some of the village's most prominent citizens.

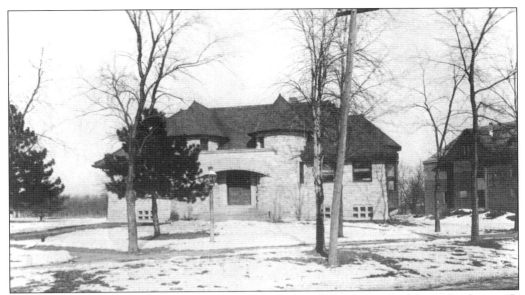

The Walker Library at Morgan and Armida, now 111th and Hoyne, was built in 1890. George C. Walker, president of the Blue Island Land and Building Company, donated the building and books to the Village. The Romanesque Revival library, designed by noted architect Charles Frost, was built of rusticated limestone and originally was intended to be part of the proposed campus of the University of Chicago. Two wings were added in 1929 after the library became part of the Chicago Public Library System. A recent renovation of the building added additional space for computers.

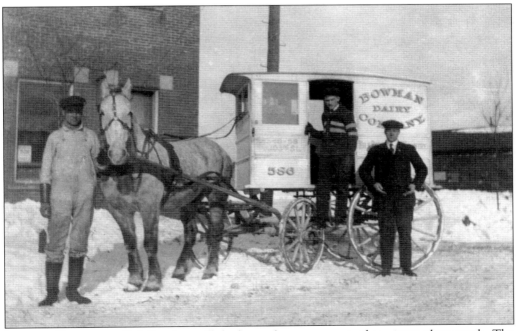

Bowman Dairy was still delivering milk by horse drawn wagon in this winter photograph. The milkman and other delivery men were a neighborhood fixture in communities around the country before the advent of super markets. Bowman was one of two dairies that served the area.

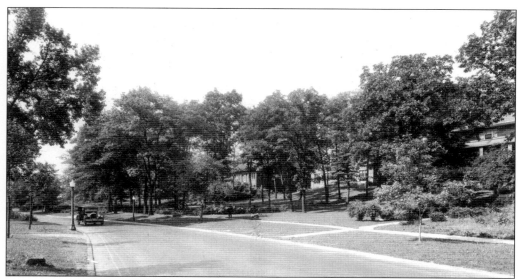

Longwood Drive is one of the most picturesque streets in the city, as illustrated by this 1920s photograph. Built along the base of the ridge, it curves and winds the length of the community. The abundance of outstanding homes found along this street was the impetus for its designation as part of a Chicago landmark district. This honor helps to preserve the distinctive nature of the community from insensitive and inappropriate development while encouraging homeowners to conscientiously preserve their properties.

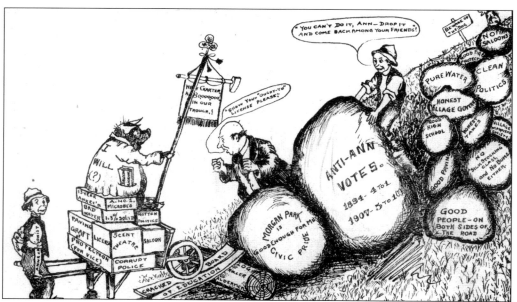

The debate over annexation raged from 1889 until 1914. This cartoon depicts the question whether or not Morgan Park should be annexed to the city. In 1914, annexationist residents (the "anns") went to the polls in Morgan Park and outvoted the anti-annexationists (the "anti-anns"). There had been seven contested annexation elections prior to 1914, with the Chicago police actually occupying Morgan Park in 1911. This long-running battle would destroy life-long friendships.

MORGAN PARK
HOME RULE ASSOCIATION

A meeting is called for SATURDAY, EVENING, OCT. 17th, at 8 o'clock, at

BLAKE HALL

to organize the MORGAN PARK HOME RULE ASSOCIATION for the purpose of opposing the present attempt to annex our village to the City of Chicago.

Chas. Courtland Smith.	G. W. Hodges.	Alfred Revoir.
F. T. Husted.	Geo. A. Winslow.	Geo. F. Emery.
W. W. Gorham.	J. W. Greenman.	E. Oliver.
Wm. L. Gregson.	F. B. Sherwood.	Dr. A. W. Woods.
F. P. Silva.	J. J. Schobinger.	Lester Bartlett Jones.
C. P. Silva.	Jno. W. Ketcham.	J. L. Lane.
H. D. Higman.	C. O. Ten Broeke.	S. F. Joor.
E. D. Dangremond.	E. D. Johnson.	A. K. Hovey.
Jno. G. Sauers.	H. S. Wetherell.	E. F. Kemp.
Frank Nay.	G. A. Cressey.	A. E. Rushton.
Chas. G. Blake.	E. T. Clissold.	O. C. Kern.
H. R. Baldwin.	Harry Thayer.	A. M. Farnsworth.
H. Clay Russell.	Cair Tourtellotte.	W. C. Kelley.
E. J. Price.	E. R. Alderson.	C. H. Huls.
Jas. R. Gray.	Willard Moffett.	J. J. Schneider.
F. J. Canty.	E. A. White.	Frank Neeb.
Fred'k. Bascom.	P. S. Stevenson.	Jule Schmidt.
Robt. J. Thompson.	E. D. Kenfield.	F. T. Colteryahn.
David Herriott.	A. E. Sturges.	N. O. Fredette.
H. R. Clissold.	Chas. A. Robinson.	P. J. Leonard.
Henry G. Myrick.	Dr. F. B. Clemmer.	Chas. E. Lackore.
Dr. F. S. Cheney.	Henry L. Ayres.	H. M. Nichols.

The names associated with the anti-annexation movement on this flyer include many of the village's prominent citizens who fought an emotional battle to prevent the Village from being swallowed by what they felt was the corrupt city that lurked at their doorstep. The issues of clean water, good schools, the sale of liquor, and political honesty helped to turn back numerous attempts at annexation. In the end the little village would become just another city neighborhood, but that independent spirit helped to maintain the unique character of the area for future generations. The sale of alcohol is still banned in the community east of Western Avenue, an ideal founded on Protestant ethics and Victorian wholesomeness.

ANNEXATION MEETING

A Public Meeting will be held at the PARISH HOUSE on

SATURDAY EVENING, JULY 20, 1912
AT EIGHT O'CLOCK

for the purpose of re-organizing the Annexation Society.

All persons favoring the annexation of Morgan Park to the City of Chicago are invited to attend. Our present situation will be discussed. It is time for effective action. Ladies are expected to attend.

Committee,

DR. W. H. GERMAN, Chairman
B. J. ASHLEY
H. J. BOHN
CLAYTON CUNNINGHAM
J. S. DERROW
F. L. KIMMEY
C. B. MARTIN

This broadside calls for a meeting to reorganize the pro-annexation movement in 1912. Despite the attempts of the "anti-anns" to paint these residents as misguided, their arguments for annexation were equally powerful as those against it. The cost of running the village was increasing, and the advantages of being part of the city centered on the benefits of affiliation with Chicago. The coming years would see many challenges that would test the mettle of the community and its institutions.

Four

FROM VILLAGE TO VILLAGE IN THE CITY

The population of the Ridge area continued to grow into the 1920s. The leading nationalities of foreign birth were German and Swedish. Institutions began to appear that would play a crucial role in the further development and vitality of the community. Beverly Bank, an institution that over the years would sponsor many social, cultural, and developmental pursuits throughout the community, continued to expand. Telephone service became increasingly available, and health care and senior housing became available with the establishment of the Swedish Baptist Home for the Aged and the Washington and Jane Smith Home. Other advantages associated with annexation began to benefit the community, such as increased fire protection, an expanded library and park system, and for better or worse, Lake Michigan water eventually replaced well water. A building boom occurred in the 1920s and 1930s that resulted in many homes being built. The area further developed as a predominantly middle and upper-middle-class neighborhood with the population actually growing during the Great Depression. While on the outskirts of the traditional Bungalow Belt, the area's large, architecturally distinctive homes, built between the late 1800s and into the 1920s, set the area apart from most of the city in terms of its diverse housing stock. Much of the present-day city was still undeveloped at the time.

By 1920, the population of Beverly had reached 7,684 residents. After World War I much of Chicago's unimproved land was used to build the ubiquitous Chicago bungalow. This building trend continued after World War II with the next generation of bungalows, commonly known as the Raised Ranch, being constructed west of Western Avenue as well as in other parts of the city. These affordable working and middle-class homes played a tremendous role in the development of Chicago. Even though there are many bungalow-style homes in the Beverly/Morgan Park community, there is no predominant architectural style in the area. Colonial, Tudor, Victorian, Italianate, Spanish, and Prairie Style homes are some of the architectural designs found in the area. The many large and historic homes built on large lots set along tree-lined streets, as well as the unique topography, helped to convey the impression of a suburb or village, distinguishing the Ridge area from the rest of the city. The 1950s witnessed another housing spike stimulated by a general post-World War II building boom and the development of the suburban Evergreen Plaza shopping mall at 95th and Western Avenue. During this period, Irish Catholics moved to the area in ever-increasing numbers, and became the leading nationality among ethnic groups.

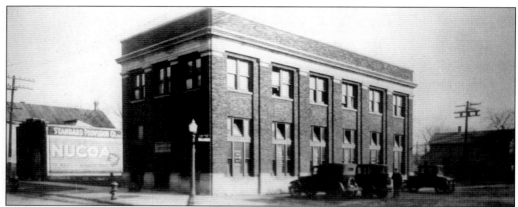

Beverly Bank, originally Beverly State Savings Bank of Chicago, was located at 103rd and Loomis as seen in this 1923 photograph. The bank's principal founders were England J. Barker, president of the United Autographic Register Company (VARCO); Emery Thomason, business manager for the Chicago Tribune; and Horace Horton, president of the Chicago Bridge and Iron Company. The bank opened in June 1923 and was founded mainly for the purpose of being a savings institution for local workers, primarily from the Chicago Bridge and Iron Company. The bank expanded several times, eventually acquiring the land west to the corner of 103rd and Charles.

A toll station for the Chicago Telephone Company was established in Washington Heights in 1886 with the first community switchboard being installed in 1898 in Albert Miller's Drug Store at 103rd and Vincennes. In 1896, a switchboard was installed at the Rock Island Depot at 95th and Wood for the Beverly neighborhood and was operated by a ticket agent, Mrs. Talley. In 1914, the residents requested that the telephone company unify all three of its local exchanges into one Beverly exchange, further cementing the area's identity. The Chicago Telephone (later Illinois Bell) switching building, pictured here, was built in 1914 at 1620 W. 99th Street. This photograph was taken in 1927.

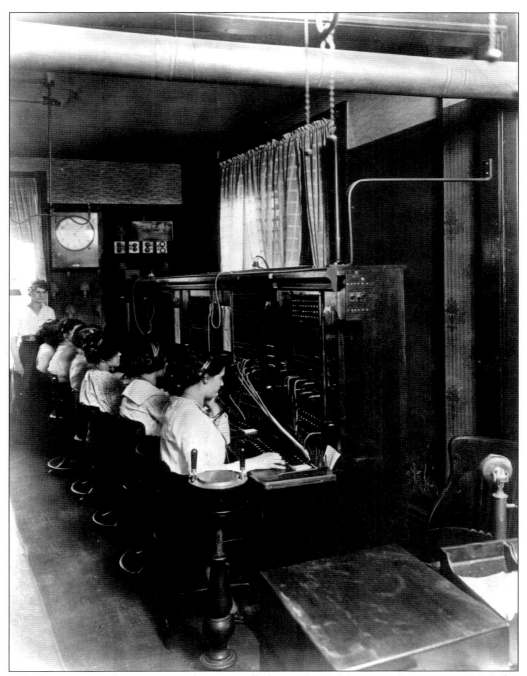

Telephone service for Morgan Park was installed at 1951 W. Monterey Avenue in 1896. Judge Lemuel T. Goe, a local justice of the peace, was the manager. When the area's exchanges were unified all switchboards were combined into a Beverly prefix. Dial service came to Beverly on May 4, 1950. This early photograph of operators in the telephone switching building shows the complexity of making a simple call in the years before direct connection service was available. In 1901, operators earned approximately $10 per month for a six-day workweek.

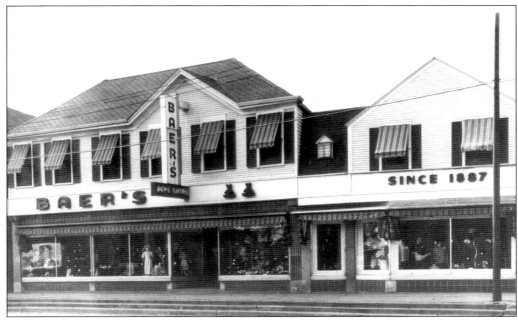

In 1938, Arthur Baer remodeled his father's dry goods store with the help of local architect George Repp. The department store sold clothing items for men, women, and children. Baer became the president of Beverly Bank in 1944 and operated the store until he sold it in 1960. The building was eventually demolished, and the land was used as a parking lot for the Beverly House Restaurant. This photograph was taken on June 5, 1941.

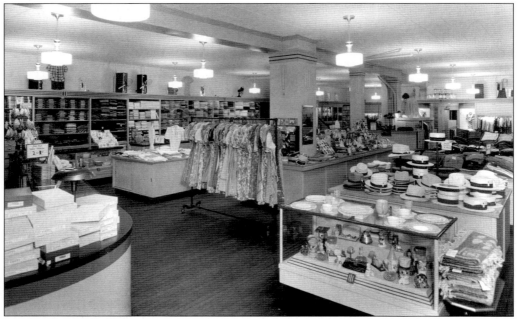

This large display of hats is a sample of the kind of items Baer's carried that were popular in 1941. Unlike a department store, Baers specialized in dry goods, predominately clothing and sundries.

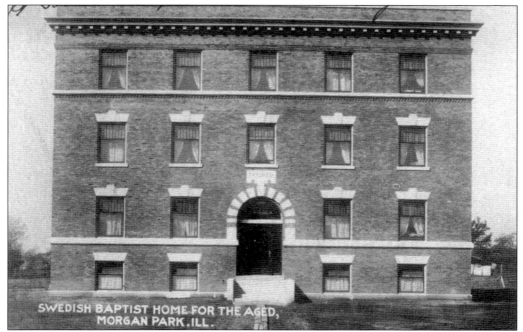

Fridheim, the Swedish Baptist Home for the Aged, gave sanctuary to the elderly who were impoverished and unable to provide for themselves. Land was purchased in the vicinity of 114th and Bell Avenue from the widow of George C. Walker in 1905. The home was surrounded by four acres that were used for pasture and gardening. It eventually became a private institution known as Belhaven. The building was abandoned and became a neighborhood eyesore and source of controversy. It was eventually demolished and replaced with a modern facility. (From the collection of Jennifer Kenny. Used with permission.)

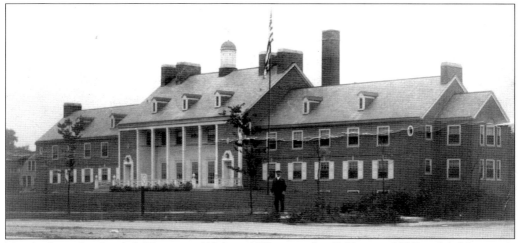

Not far from the Swedish Home on 113th and Western, the Oakhaven Old People's Home was completed in 1924 with the feeling of a home-like atmosphere. In 1929, it merged with the Washington and Jane Smith Fund, and the name changed to the Washington and Jane Smith Home. Despite additions, the colonial façade looks much the same today, and the facility continues to serve the community. (From the collection of Jennifer Kenny. Used with permission.)

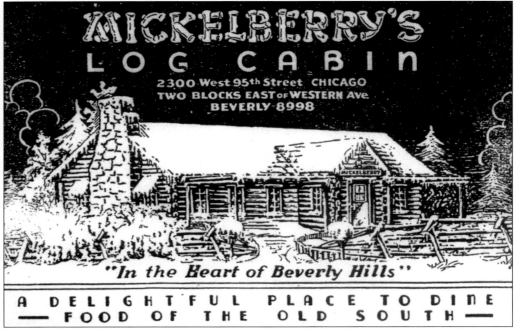

MICKELBERRY'S LOG CABIN

2300 West 95th Street CHICAGO
TWO BLOCKS EAST of WESTERN Ave.
BEVERLY 8998

"In the Heart of Beverly Hills"

A DELIGHTFUL PLACE TO DINE
— FOOD OF THE OLD SOUTH —

Mickelberry's Log Cabin Restaurant was located at 2300 W. 95th Street. Charles Mickelberry, son of William M. Mickelberry, founder of the Mickelberry Sausage Company, opened the quaint restaurant in May 1933. Many residents have fond memories of the restaurant. Its rustic décor featured a large collection of Americana, and Southern cooking was served. In 1940, Charles was appointed as a member of the Committee on Federal Legislation of the National Restaurant Association based on the recommendation of the Beverly Lions Club, of which he was an active member. Charles Mickelberry was born in Atlanta, Georgia in 1880. He moved to Chicago in 1892 and died in 1948.

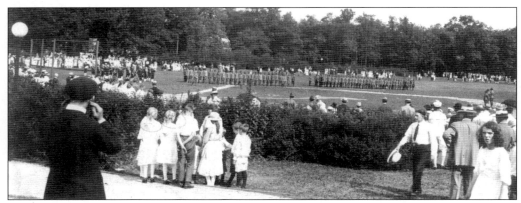

Ridge Park, located at the base of the ridge at 96th and Longwood, opened in 1910 before the Chicago Park System was unified. P. Clyde Perry formed the Ridge Park Association, and the park was originally platted between 99th, 101st, Hoyne, and Damen, for the lowland east of the ridge was a swampy marshland that had to be drained before the park could be built. The field house building was completed in stages starting in 1913 with the last addition built in 1929, designed by John T. Hetherington. The pool was enclosed and an art gallery was added to house the Vanderpoel art collection. This photo was taken in 1914.

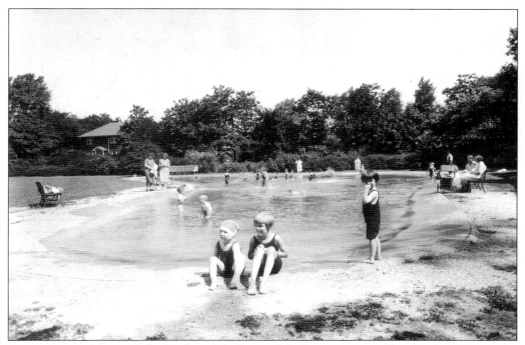

Erastus Barnard donated the land used for Barnard Park in memory of his daughter Amy, who died in 1888 at the age of 20. The park is located on Longwood Drive and 105th, along the Rock Island railroad tracks and just west of the old Barnard homestead. The wading pool in this photograph, taken about 1928, has since disappeared.

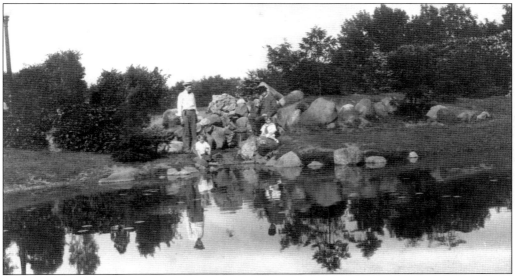

Prospect Park was the jewel of the Calumet Park District. Its landscaping was designed by noted naturalist Jens Jensen. Jensen's philosophy for park design was to replicate the prairie landscape that would have existed before the arrival of settlers. The park included a rock garden, pond, and waterfall. The homes of many of Morgan Park's early influential residents were located around the park. This photograph was taken about 1910.

The Beverly Bank was more than a place for the local residents to keep their money. It played an active role in community life under the progressive leadership of Arthur Baer. The bank sponsored numerous community events, sports teams, and charitable causes. Baer, and his wife Alice, took particular interest in preserving the quality of life in the area while embracing the racial changes that were taking place in the 1960s. His support for institutions such as the Beverly Art Center, BAPA, and the Ridge Historical Society helped to promote an active cultural life and maintain community stability. The bank lost its identity when it merged with other financial institutions, and is no longer under local ownership. This is the interior of the bank as it looked in 1946.

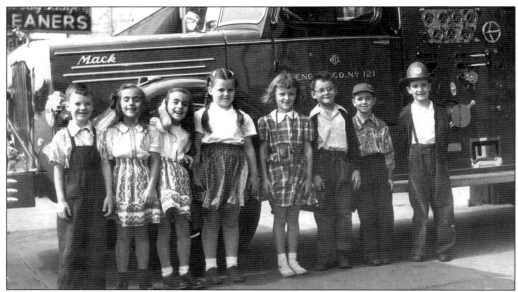

These children seem to be enjoying their visit to Engine Company Number 121 at the firehouse on 95th and Charles. This firehouse is home to one of the three companies that protect the Ridge communities. One of the advantages of annexation to the city was the increased fire protection it afforded.

Five

GOD'S WORK

Religion has always served an important role in the life of newcomers to a community. Religion and houses of worship gave immigrants throughout the city a means to retain their culture, language, and identity while providing people new to an area with a sense of belonging. The building of a church was often as much a way for ethnic groups to provide themselves with an identity, as it was to create a place to worship God. By the 1870s, an increasing number of people began moving south to Washington Heights due to expanding transportation opportunities. The majority of these were white Protestants, and many were members of Chicago's economic elite. After 1880, most new residents of Beverly and Morgan Park were Protestants who had left Hyde Park, Englewood, and Normal Park. This movement was precipitated by increased urbanization and a change in the ethnic makeup of those communities, often due to an influx of Irish Catholics. Protestant institutions began to appear, including the Bethany Union Church, built in 1874. The religious life of the community was dominated by a number of Protestant faiths, including Methodists, Baptists, and Lutherans.

By 1924, many Irish Catholics began moving into the neighborhood, and despite the opposition of established Protestants faiths, built St. Barnabas Church. The tension between these communities has parallels with the later growth of the African-American population in the cities, and was not unique to the Ridge. The friction between Catholics and Protestants was indicative of a virulent nationwide nativist response to immigration that existed since the early 19th century. The Irish were often viewed as drunks and criminals, and many Americans were alarmed about their increasing numbers and influence in politics. Catholics found this opposition in many parts of the city and throughout the nation. The first attempt by Rev. Timothy Hurley, first pastor of St. Barnabas Church, to obtain land at 100th and Longwood to build a church was foiled when local residents were successful in having that parcel of land condemned for use as a park. This despite the fact that Ridge Park was only four blocks away. Father Hurley pressed on and obtained land for the church on Longwood Drive at 101st Place. In May 1924, construction began on St. Barnabas Catholic Church, and in July of that year the Ku Klux Klan burned a cross in front of the church to protest its construction. Protestant opposition would continue in the area for many years to follow. Ironically, the park used to block the first attempt to build a church was later named Hurley Park. The friction eventually abated, and the Beverly/Morgan Park Catholic community came to be centered around its numerous parishes, as it had in so many other neighborhoods on Chicago's South Side.

The Evangelical Zion Lutheran Church at 99th and Winston was founded in 1870 by 18 families of German origin, with buildings built in 1891 and 1937. Bethany Union Church also held services here beginning in 1872, until their church was completed in 1874. Zion Lutheran is the oldest congregation in the community. (Photograph courtesy of Bethany Union Church.)

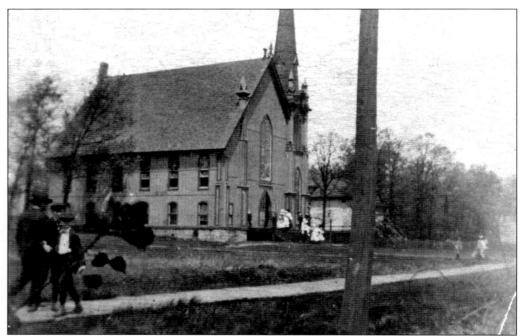

Bethany Union's first church was built at 103rd and Prospect Avenue in 1874. Fourteen charter members of six denominations founded the church, "for the moral and religious welfare of the community." Among the 14 were Elizabeth Barnard, a Congregationalist, and Alice Barnard, a Presbyterian. The name "Bethany" was chosen because of the number of times it is mentioned in the New Testament in reference to the life of Jesus. To accommodate a larger congregation, a new church was built on 103rd and Wood and held its first service in 1905. Drew Street was named for the Rev. J.B. Drew, also one of the charter members of the church. Church Street was named for the Rev. L.S. Church, who would later join Reverend Drew.

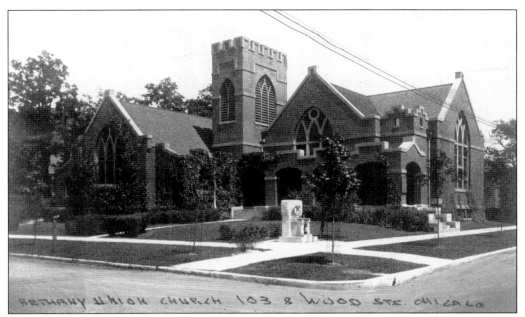

An expansion project sees the construction of a new Bethany Union Church at 103rd and Wood. This building was completed in 1905. In 1926 a new sanctuary was completed adjoining the older building on the east side. A new two-story educational building was completed in 1955, after the demolition of the old assembly room building.

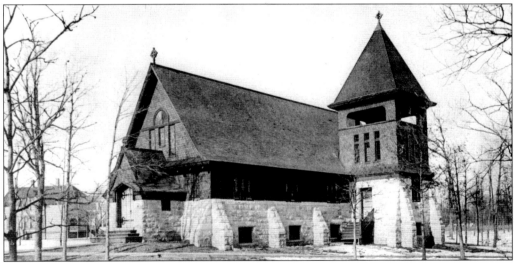

The Church of the Mediator on Armida Avenue, now 10961 Hoyne, was built in 1899. This Episcopal congregation was first organized in 1878 and first met in Washburn Hall until the congregation's own church could be built. In 1929, a new sanctuary was built and the old building became the parish house. The old Baptist Theological Seminary library, which was later moved to 11057 Hoyne and converted into an apartment building, once served as the parish house for this church. The original church building was demolished in 1956 and replaced by a new south wing parallel to Hoyne. This photo was also taken in 1899.

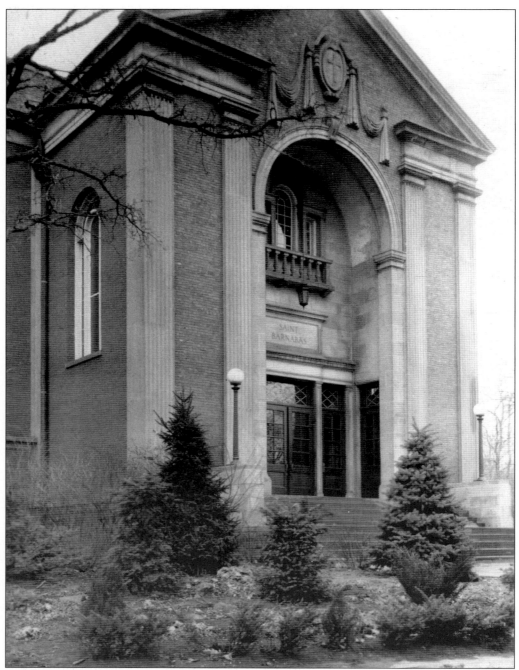

St. Barnabas Catholic Church, located at 101st Place and Longwood Drive, opened in 1924. This photograph shows the original church, which also included a school. In 1968, a new church replaced this building and the school moved across the street. Other Catholic churches followed. St. Cajetan was organized in 1927; Christ the King in 1936; St. John Fisher in 1948; St. Walter in 1953; and St. Margaret of Scotland was organized as a mission church sometime between 1861 and 1874 in Blue Island before finally relocating to 99th and Throop.

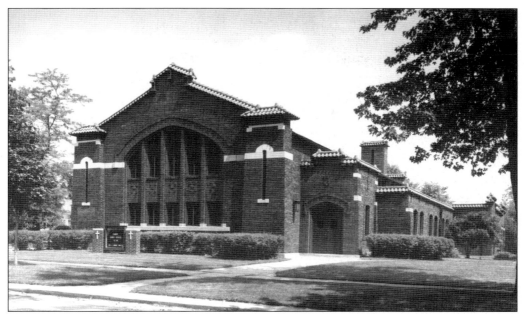

In September 1886, six people, including the Reverend and Mrs. C.S. Uzzell, organized what would become the Morgan Park Congregational Church. Reverend Uzzell and Col. George Clarke, a prominent local resident, were associated with the founding of the Pacific Garden Mission in downtown Chicago. The Congregational Church building was built in 1891 at what is now 112th and Hoyne. This new church was built directly across the street at 11153 Hoyne in 1915. The original building, still standing, was later used as the Masonic Lodge Hall.

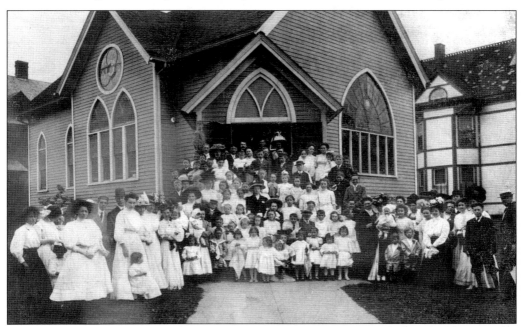

The members of the Congregational Church are shown in front of their building in this photograph from 1909. The building is now home to the Plaid Academy, a private school.

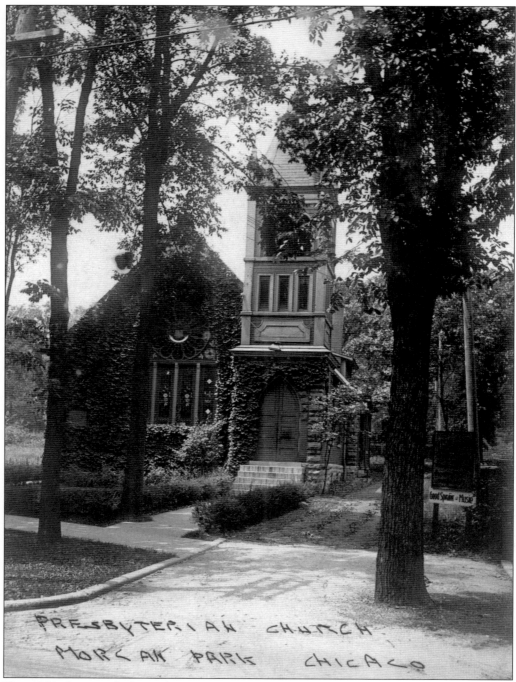

This 1899 photograph shows the Morgan Park Presbyterian Church at Prospect and Arlington, now Longwood and 110th Place. The church was organized with 29 members in 1891 and services were held in Blake Hall of the Morgan Park Military Academy until the church building could be completed. The first church was built in 1891 and burned in 1933. (From the collection of Jennifer Kenny. Used with permission.)

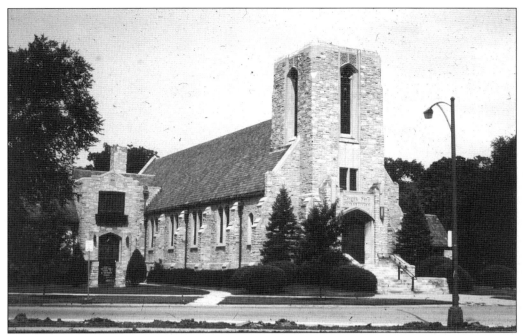

This photograph shows the church built in 1940, on the same site as the original Morgan Park Presbyterian Church, to replace the structure destroyed by fire.

St. Paul's Union Church held its first meetings between 1892 and 1894 in the Longwood Station (95th Street) of the Rock Island. The church was formally organized by a council of representatives of Presbyterian, Congregational, Reformed Episcopal, and Union Churches as a "union" or nondenominational church. The original building is now a residence located at 1748 W. 96th Street. The second church building was built between 1902 and 1903 at 94th and Winchester. The second building was destroyed by fire in 1942, and was replaced by the current building in 1943.

Trinity Lutheran Church at 1430 W. 100th Place was organized in 1881. Some of the founders were members of the Zion Lutheran Church on 99th and Winston, with the first meetings held in a business on Tracy Avenue. The entire church was moved to the current location in 1884, and the building was then enlarged in 1900. When the current church was built in 1893-4, and the old church building was moved to face 100th Place and enlarged, it served as the parish hall until 1957 when the new building was completed.

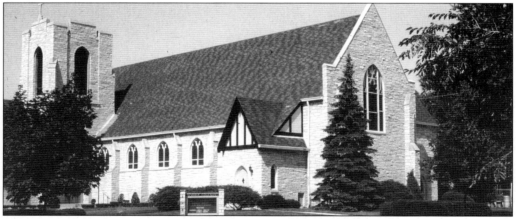

Beverly Evangelical Covenant Church, at the corner of 106th and Claremont, has its roots in the merger of two older churches. The Swedish Bethany Church, organized in 1882, was located at 5423 S. Wells. The name was later changed to Bethany Mission Covenant Church in 1890. A new church was built in 1892, but was later faced with a racially changing neighborhood, so they sold the building in 1949 and relocated to new building that was built in 1950 at 91st and Bishop. Redeemer Evangelical Covenant Church, organized in 1888 and originally Englewood Covenant Church, was located on Morgan Street at 59th and Peoria. A larger church was built in 1898 at 59th and Carpenter, but confronted with the same racial changes that swept the South Side, relocated to 106th and Claremont in 1952. The two churches merged in 1969, adopting the name Beverly Evangelical Covenant Church.

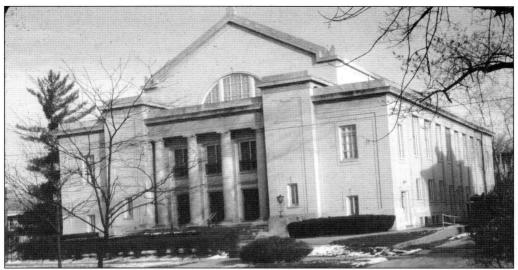

The Christian Science Church at 10317 Longwood consisted of members of Fourth Church of Christ Scientist of Englewood. In 1914, they organized the Thirteenth Church of Christ Scientist and met in Tracy Hall. Their own church was built in 1916 at 10317 Longwood, and designed by architect Howard L. Cheney. The property for the reading room on 103rd was purchased in 1933 and the building completed in 1940. The church was sold and converted to residential condominiums, but the reading room building is still maintained for use by the public.

The Morgan Park Methodist Church was organized in 1887 at the urging of local physician Dr. William German. Early meetings were held in Washburn Hall until a church was built in 1888 at Prospect and Homewood. As the membership grew from the original 18 members, a new church was needed and would eventually be built at 110th Place and Longwood in 1913. This is a photo of the building as it looked after it was enlarged in 1926 to occupy the entire block. This building was designed by H.H. Waterman.

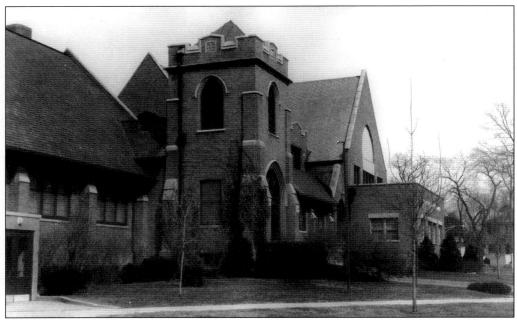

Morgan Park Baptist Church, at 110th and Bell, is the oldest congregation in Morgan Park and was organized by Thomas Goodspeed of the Baptist Union Theological Seminary in 1877. Dr. William Rainey Harper, who established the American Institute of Hebrew in Morgan Park, was the first superintendent of Sunday school classes. These men went on to play prominent roles in the development of the University of Chicago, and an early effort was made to locate the University in Morgan Park. The first church, built in 1874, was destroyed by fire in 1896. The current church, seen in this 1976 photograph, was built in stages between 1896 and 1954.

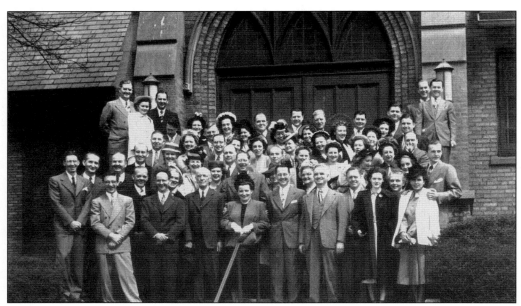

Members of the Morgan Park Baptist Church congregation are seen at the main entrance in this undated photograph.

Six

EDUCATION AND
SOCIAL LIFE

Education has always been an important aspect of life on the Ridge, and early residents took education seriously. The community continues this tradition and is the home of some of the finest public and parochial schools in the city. In 1972, Kellogg Elementary School was the top public school in the city based on reading achievement test scores. Clissold School was first in 1973. The Ridge developed as a cultural center as far back as the late 1800s through the influence of W.M.R. French, first director of the Art Institute of Chicago, and his protégé, artist John Vanderpoel. Vanderpoel would have a school and street named in honor of his contributions. The area has played host to a variety of cultural, athletic, and social events and activities over the years, many sponsored by various civic and religious groups. Over the years these have included Fourth of July and Memorial Day celebrations, home tours, and parades. These events have given residents a chance to socialize, enjoy a favorite pastime, display their patriotism, and show off their neighborhood.

Change is inevitable in every community, and the Ridge was no exception. A new expressway was planned in the 1960s to run through Morgan Park. The 1960s also brought about a decline in some of the business districts that long characterized village living. Some buildings that were symbolic of the uniqueness of the Ridge fell prey to the wrecking ball. By 1970, many people began to leave the area. Property taxes had risen, an energy crisis had occurred, and high interest rates coupled with a decrease in property values made the area a less attractive investment for homebuyers. The Ridge also began to see the onset of racial integration. The racial makeup in the neighborhoods near Beverly and Morgan Park, including, Roseland, Brainerd, Gresham, and Auburn Gresham underwent re-segregation. Many in the predominantly white area feared that the large number of African Americans moving into the area would result in a decline in home values and financial loss, an increase in crime, and schools deteriorating and becoming unsafe. Many people believed the Beverly/Morgan Park community would undergo decline and be re-segregated like many other neighborhoods in Chicago. This, however, would not be the case in Bevery and Morgan Park. Whereas other Chicago neighborhoods collapsed under the weight of integration, the Beverly/Morgan Park area is one of the best examples of racial integration in the city and a success story unto itself. While the last few decades have brought about change along the Ridge, there has also been a renewed sense of pride that has manifested itself in the form of organizations and events that celebrate the uniqueness of the area while also offering residents various cultural and recreational opportunities that continue to strengthen the community.

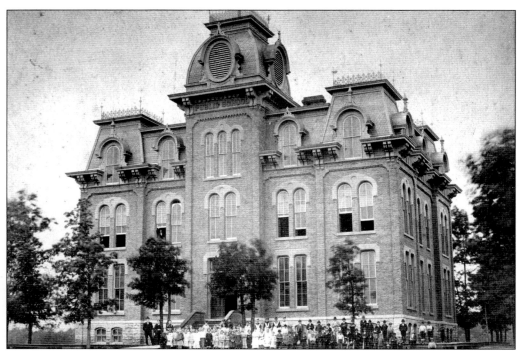

Washington Heights School was located at 104th and Charles, and opened in 1875. The school in this picture was destroyed by fire in 1890. The lower grades were then transferred to Tracy Hall and to Dummy Junction School, located at 99th and Aberdeen. Upper classes were held in the Town Hall, near the location of present-day Graver Park. The high school, named Calumet High School, moved to Auburn Park (modern-day Auburn Gresham) in 1891 following the annexation of Washington Heights. A new school was built on the same site of Washington Heights School in 1893 and named in honor of Alice Lucretia Barnard.

Esmond School, located at Esmond and Meadow (Montvale) Streets, was built in 1891. The first school in Morgan Park was organized between 1854 and 1863, and classes were first held in a small schoolhouse. A schoolhouse was built in 1873 and subsequently replaced by the Esmond School in 1891. The building, shown as it looked not long after construction, still stands and serves local students. The turret cap and chimneys have been removed, and other structures added to increase class space.

The graduates of Esmond School, prior to 1900, came together on July 1, 1924 for a skit they preformed for the Morgan Park Historical Society. The play, titled *Ye Village School*, was a dramatization of classroom antics. The reunion was prompted by the reminiscences of Miss Elizabeth Myrick, the first teacher at Esmond (later nicknamed the old Prairie Academy by graduates) on April 5, 1923 for the Morgan Park Historical Society. Edward Clissold is pictured in the front row on the left and Ivan Mansfield, the "teacher's pet," is in the front row fourth from the left. Miss Myrick is fifth from the left in the second row.

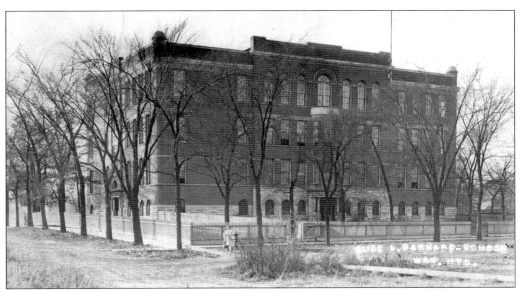

Barnard School, located at 104th and Charles, was built in 1893 to replace the Washington Heights School after it burned down. The school in this picture was subsequently destroyed itself by a spectacular fire in 1940.

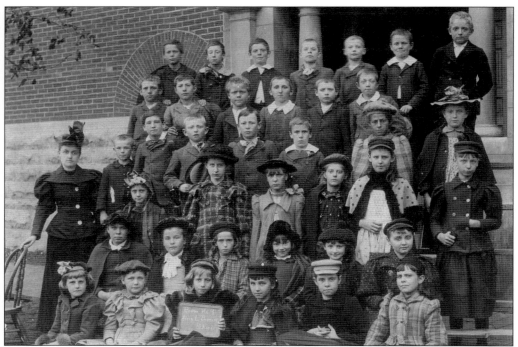

The Barnard Class of 1895 is pictured here. This photo was donated to the Ridge Historical Society in 1976 by Lillian Kistner, who is pictured at the left of the front row in this photograph. At the time she donated this photo, Miss Kistner was the oldest living graduate of this Barnard School. class

Arlington School, as it looked in 1905 when it was built, was right next to the Western Avenue School. The buildings were virtually identical. Arlington was the Morgan Park high school until the new high school was finished in 1916. After the new high school was built, Arlington housed the fifth through eighth graders until it was demolished in 1931 when Clissold School was completed.

The Sutherland School, at 100th and Leavitt, was completed in 1926 and was named after Elizabeth Huntington Sutherland, a prominent local educator. Sutherland was a branch of Barnard School, and the original Sutherland School was actually a series of small buildings that were built on 101st Street between Hoyne and Leavitt.

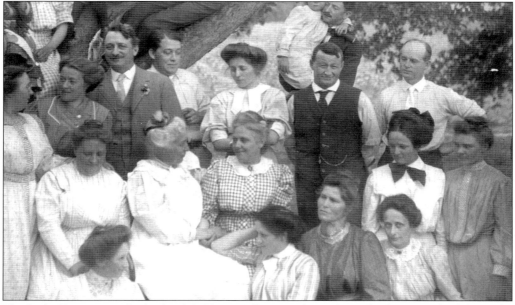

Elizabeth Huntington Sutherland (1821–1925), second row from the bottom, third from the left, is seen in this 1909 photograph. She was among the first women in Cook County to be appointed as a principal, and served in that position at the Barnard Elementary School for 39 years beginning in 1893.

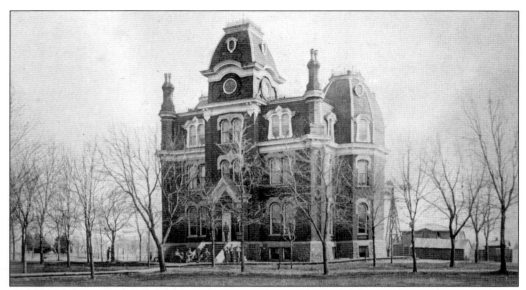

Park Hall of Morgan Park Military Academy was located where the current gymnasium stands. The academy was first established as Mt. Vernon English, Classical, and Military Academy in 1873. It became Morgan Park Military Academy in 1877. From 1892 to 1907, it became a prep school for the University of Chicago, then turned back into a military school in 1914, and finally into a co-ed prep school in 1959. The campus originally included other buildings that were part of the Baptist Theological Seminary. These buildings have long since disappeared and included such structures as Blake Hall and Morgan Hall.

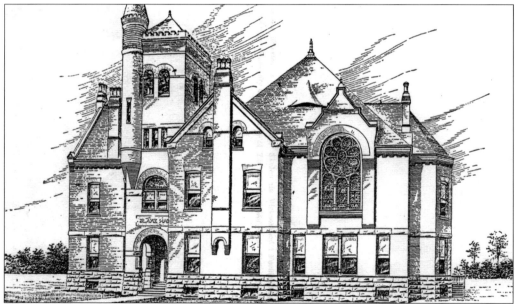

Blake Hall of Morgan Park Military Academy at 2153 W. 111th Street was built in 1888 and demolished in 1962. This was the administration building of the Baptist Union Theological Seminary and the administration building for the Academy. The first Beverly Art Center was built on this site and opened in 1969.

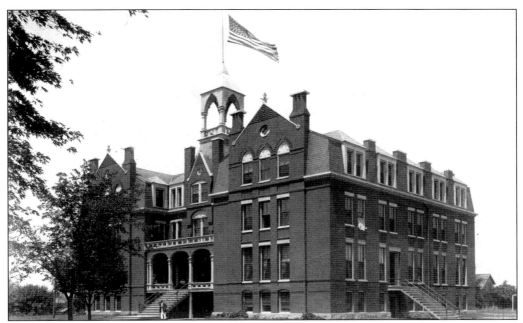

Morgan Hall of Morgan Park Academy was originally Seminary Hall of the Baptist Union Theological Seminary, which stood at what is now 2140 W. 111th Street from 1877 until about 1915 or 1916. Thomas W. Goodspeed and Dr. William Rainy Harper headed the Seminary. The Blue Island Land and Building Company convinced the Seminary to move to Morgan Park in 1877 from the Douglas neighborhood with a donation of five acres of land. A strong bid was made to make Morgan Park the location of the new University of Chicago, but the Seminary was absorbed into the University of Chicago in 1892 and relocated to Hyde Park.

The Chicago Female College (Seminary) was located atop the ridge at Raymond Street, now 114th Place. The Blue Island Land and Building Company originally intended the building to house a sanitarium, but it became a girls' high school similar to the boys' Morgan Park Military Academy military school. It was founded in 1875 as a boarding school by Dr. Gilbert Thayer, who served as its principal. Thayer was also a member of the first Morgan Park Board of Trustees. The Female College was at this location from 1875 until 1892, and might have operated briefly from the Givins Castle. After 1892, the building was called Walker Hall, and used by the Scandinavian division of the Baptist Theological Seminary until it was torn down in 1911.

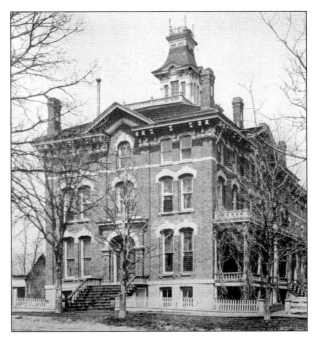

The cadets of Morgan Park Academy are seen in drill practice on the Jones Bowl in this undated photograph. Hansen Hall is seen on the left and Blake Hall is in the center of the picture.

The Academy cadets cut a fine figure in this undated photograph. Col. Harry Abels commanded the school for many years, beginning in 1919 when he was appointed superintendent, and was instrumental in establishing the school's fine reputation. Abels served as an instructor of Physics and Chemistry and principal of the school prior to the introduction of military training in 1914.

After a long campaign by residents for its construction, the new Morgan Park High School was completed in 1916. Not long after its completion it quickly became overcrowded, necessitating a split of classes to other local schools. A new addition in 1926 created a third story atop the original school, and included a swimming pool, auditorium and gymnasium. Noted for a commitment to quality education throughout its history, it ranks among the best public schools in the city.

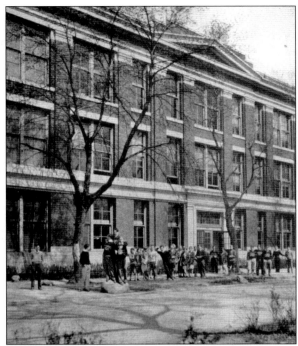

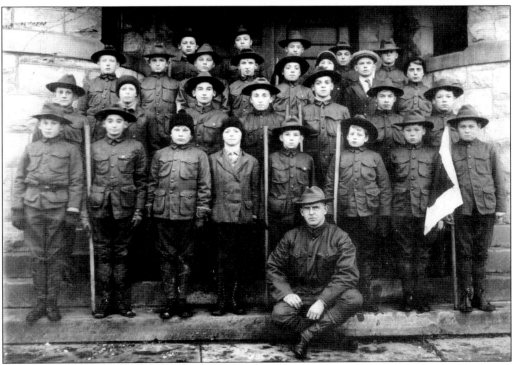

The Pioneer Troop of the Morgan Park Boy Scouts, led by Scoutmaster Gair Tourtellot Sr., is seen in this 1913 photograph taken on the steps of the Walker Library. The Scouts have long a tradition of providing activities and developing skills for the young men of Beverly and Morgan Park.

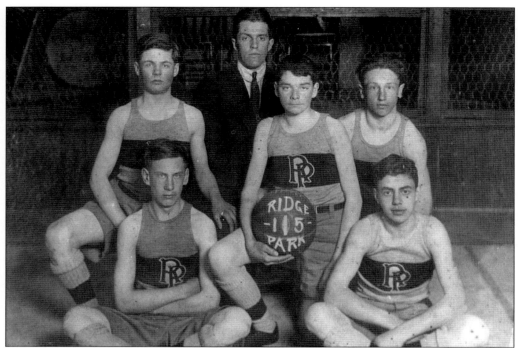

The Ridge Park basketball team played in the gymnasium at Tracy Hall on 103rd Street, where this photograph was taken. Arthur Bear, future president of Beverly Bank, is the young man on the bottom right.

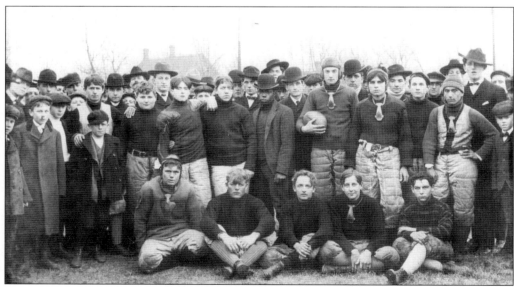

This 1902 photograph shows the Washington Heights football team. At this point in the sport's history it bore a stronger resemblance to English rugby than to the modern day version. The odd-looking nose guards hanging from the player's necks as well as the quilted pants are noteworthy, as is the lack of body padding. This was not a game for sissies!

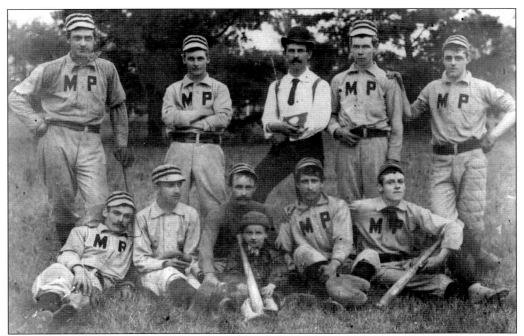

Baseball lovers will enjoy this late 19th century photograph of the team of "nine good men" from Morgan Park. The uniforms, the manager in a derby hat, and the diminutive "bat boy" make for an interesting image from the classic age of baseball.

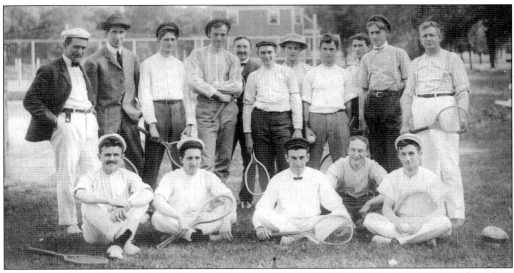

Members of the Morgan Park Tennis Club are shown in this 1907 photograph. Edward T. Clissold, pictured second from the left in the front row, was the son of Henry Clissold, after whom Clissold Elementary School was named. Henry came to Morgan Park in 1863. Henry worked for four newspapers, was a director of the Calumet Savings and Trust Bank, and was the first clerk of the village board. Edward was the founder of the Euterpean Glee Club, and in 1919 succeeded his father as owner of the Bakers Helper, the largest trade publication in the country devoted to the commercial baking industry.

The pond of the first Ridge Country Club was located at what is now 103rd and Hoyne. The club was originally located on grounds bounded by 103rd, 106th, Western Avenue, and Seeley. The clubhouse was located on 103rd between Bell and Leavitt. Christian Zeiss, the owner of the Hopkinson-Platt House, was a co-founder of the club. Committee meetings to organize the club were held at his house, which was chartered in 1902. This pond served as a skating and hockey rink for area youngsters before it became part of the country club. The club relocated to its present site at 105th and California in 1916, and the original site was developed with homes.

Edward T. Clissold conducted the Euterpean Glee Club of Morgan Park for 35 years in many popular compositions, such as Handel's "Messiah" and Mendelssohn's "Elijah," with performances often held at the Morgan Park Baptist Church. Clissold organized the club in 1900 at his home at 2126 W. 110th Street as an all men's chorus. The club reached the height of popularity in the early 1950s when it boasted 125 singers. The Euterpeans performed in the Hall of States to celebrate Illinois Day at the 1933 World's Fair in Chicago. This photo, taken in 1912, shows the group in front of the Parish House. Clissold, pictured second from the left in the third row, died in 1943 at the age of 70.

Established in the 1920s as an activity of the Chicago Park District, the Beverly Theatre Guild staged productions in the Ridge Park field house. The group ended its affiliation with the park district in 1962 and became a not-for-profit community association sustained solely by its own revenues. This photograph shows their production of *Seven Keys to Baldpate* at Ridge Park on May 25, 1939.

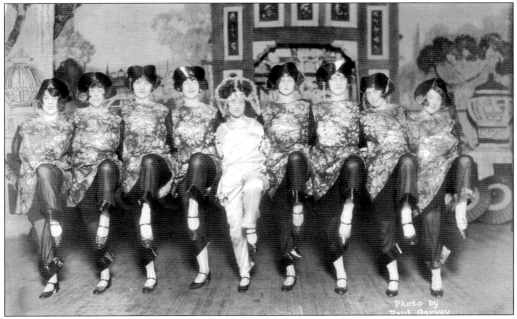

Members of the Junior Auxiliary of the Beverly Hills Woman's Club kick up their heels in this undated photograph. The group often performed elaborate annual productions with exotic themes. The Beverly Hills Woman's Club was founded in 1908 as the Mothers' Club. It was later known as the Ridge Mother's Club, Ridge Woman's Club, and in 1926 assumed its present name.

Uncle Sam and John Bull make an appearance at the Longwood Fourth of July celebration in 1909. These patriotic events drew scores of costumed participants, some dressed in rather bizarre attire, to celebrate the nation's birthday. Longwood was a neighborhood in Washington Heights near the 95th Street train station and is now a part of Beverly and North Beverly.

Swing your partners and doe-see-doe! Square dancing was a popular pastime even for city folks, as evidenced from this photograph taken at the Morgan Park Methodist Church. It was fun, you got to hold hands, and everyone looks like they're having a good time.

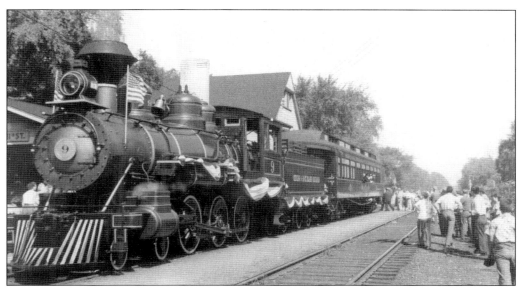

The Rock Island celebrated its 100th Anniversary in 1952. The train pictured in this photograph was a re-creation of the original "Rocket" that ran from Chicago to Joliet on the first day of service. The fact that the Blue Island Branch line was built quite some time after that auspicious day did not stop the community from celebrating the event. The train made a round trip to Blue Island from the downtown LaSalle Street Station with invited guests enjoying onboard refreshments and a picnic lunch. This was just one of many celebrations in towns and cities across the Rock Island System.

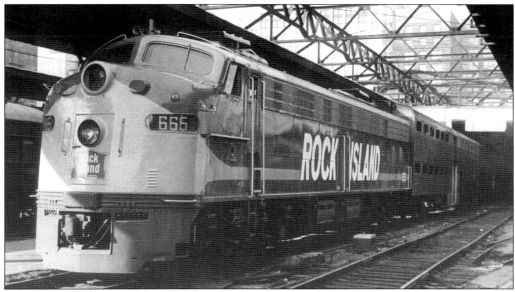

Dieselization of the suburban commuter trains took place in the 1960s. "The Rock" disappeared in the bankruptcy frenzy that swept through the American railroad industry in the 1970s, and it was feared that the convenient commuter train service the community enjoyed would cease to exist. The formation of the Regional Transportation Authority would save Chicago's extensive commuter rail system and begin a process of rehabilitation and expansion of this valuable service.

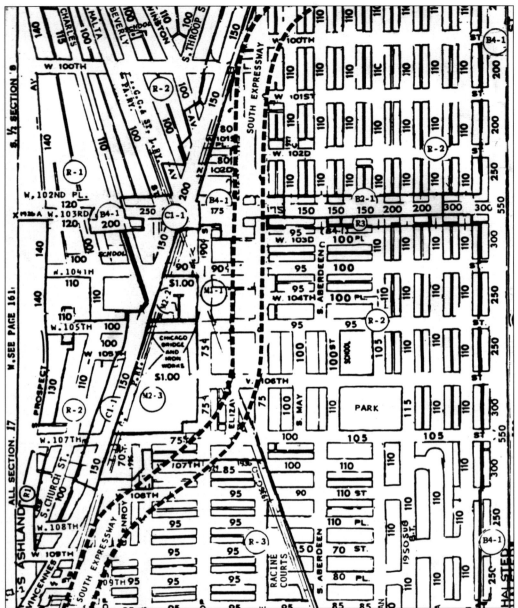

This map shows the proposed South Expressway (I-57) that was completed in 1967 and runs through the eastern edge of Morgan Park. The location of many of the city's expressways was controversial in that they were often used to demarcate and solidify racial boundaries. A federal housing program that aided the construction of hundreds of small homes between 1969 and 1974 along Vincennes Avenue was a well-intentioned program that created serious difficulties. The addition of these subsidized homes strained the local school system with a flood of low-income students and threatened to overwhelm the racial balance of the community. These types of planning decisions, made without input from local residents, were a catalyst for citizen initiatives to have a greater voice in the community's destiny. (This map appeared in *Olcott's Land Values Blue Book of Chicago, 1967*.)

A photograph of the Barnard Elementary School class of 1970 is an example of the racial integration that took place in the 1970s. In 1971, L. Patrick Stanton worked with members of the community relations committee of the Parish Council for Christ the King Catholic Church on a proposal called "Beverly Now." The proposal called for a local organization designed to face the potential problem of racial re-segregation, which was confronting many Chicago neighborhoods. The goal was to have the Beverly/Morgan Park community integrate more successfully than other neighborhoods had done.

Under the leadership of L. Patrick Stanton and G. Philip Dolan, a community planner brought in from Columbus, Ohio, the Beverly Area Planning Association was instrumental in adopting a racial integration maintenance program and combating white flight throughout the neighborhood. Led by Mary Quinn Olsson of BAPA, along with the Ridge Historical Society, one of BAPA's greatest achievements was its persistence in getting the Beverly Hills/Morgan Park area designated a federally recognized historic district in 1976. The organization promoted the slogan "Village in the City" to refer to the small-town nature of the Beverly/Morgan Park community.

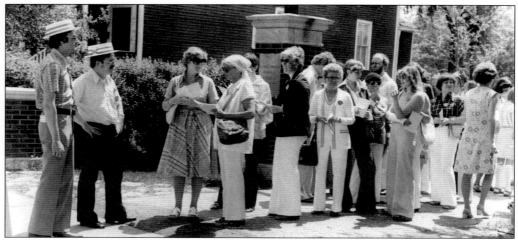

The genesis of the annual Beverly/Morgan Park Home Tour was through an event sponsored by the Ridge Historical Society. The Beverly Area Planning Association would expand it into one of the community's most successful events. Originally founded in 1946, BAPA was composed of a number of civic organizations, and tackled community problems such as zoning and parking. In 1972, it led the efforts to maintain the stability of the neighborhood during the uncertain period of racial integration. The city's 1976 residency ordinance that requires city workers to live in the city also helped prevent further white flight and brought many middle level and upper level municipal employees to the community.

Morgan Park already had an established African-American population since its founding, but the challenge of integration confronting the larger community in the 1970s revived a strong sense of community pride and activism that was instrumental in preventing people from leaving the area. Today, the Beverly/Morgan Park community is an example of a successful neighborhood endowed with a strong sense of community pride and participation.

Students from Morgan Park High School appear with Governor Daniel Walker, a former resident of Morgan Park, in this photograph from March 16, 1973. In an effort to maintain racial stability, officials from the Chicago Board of Education and community organizations in Beverly and Morgan Park reached an agreement in the late 1970s for a balance of 50% white to 50% black enrollment in Morgan Park High School. The Chicago Board of Education discarded the quota system at Morgan Park High School in 1980. The Catholic Youth Ministry was formed in an effort to show area Catholics that the public high school was a viable option for their children. The Ministry plan was developed by BAPA and the pastors of four neighboring parishes with a twofold purpose: to promote religious education and help maintain racial stability.

Beverly Bank sponsored many charity events, one of which was the American Cancer Bike-A-Thon. This photograph shows some of the participants, and is notable for the racial mix of the riders. The 1960s and 1970s were a tumultuous period between the races, and events like this one allowed people to get together in a non-confrontational atmosphere to work for a common cause. The community today is a desirable destination for homeowners of all races thanks to the efforts of the many groups who refused to succumb to panic and paranoia.

The Beverly/Morgan Park Community celebrated its 150th Anniversary with a Sesquicentennial Celebration in 1972. Pictured from left to right are Mrs. Margaret Lang, president of the Morgan Park Improvement Association; Don O'Brien, dinner chairman and president of the Beverly Improvement Association; and Mrs. Harriet Platt. The trio is inspecting a map of Indian trails that once ran along the Ridge. The year-long celebration marked the date when French Canadian fur trader Joseph Bailly De Messein traded with the Native Americans of the Ridge and married a chieftain's daughter.

De Witt Lane, great grandson of the 1832 settler; Mrs. Eleanor Pillsbury, co-founder of the Beverly Art Center; and P. Clyde Perry, founder of the Ridge Civic Association are pictured inspecting a model of Fort Dearborn during the Sesquicentennial Celebration. Members of the event dressed in period costume and told stories of pioneering days on the Ridge.

The earliest Girl Scout troops in the community date from the 1920s. The Girl Scout movement in America began in 1912 and was inspired by a similar program for girls in England. This 1974 photograph shows the junior scouts of Girl Scout Troop 303 from St. John the Devine Evangelical Lutheran Church. From left to right are: (front row) Cynthia Jillson, Monica Rieg, Anna Ficht, Mary Beth Maher, and Stacey Rust; (back row) Ellen Hopkins, Dana Zoeller, Leslie Eubanks, Elizabeth Burke, and Kathy Curme.

The roots of the current popularity of Irish dancing are in communities like Beverly, where it was preserved and nurtured through the efforts of local dance studios. Some of the best practitioners of this unique art form come from the area. The Irish make up one of the largest ethnic groups in the area, and their identity has become entwined with that of the community. They maintain a strong hold on local politics, and the names of numerous local businesses attest to their dominance in the community. The Southside Irish Parade, an event that began as a small, family oriented event, has grown in popularity to surpass the annual St. Patrick's Day parade held in downtown Chicago.

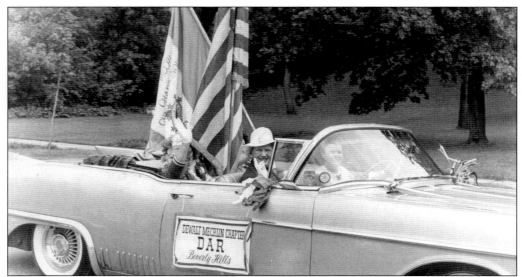

The Memorial Day Parade is one of the great annual events in the community. It begins near 111th Street and winds its way north on Longwood Drive to Ridge Park. There are marching bands, marchers, antique cars, and anything on wheels. It is open to everyone and local residents line the parade route, cheering each participant as they pass. This picture from the 1970s shows members of the Dewalt Mechlin Chapter, National Chapter of the Daughters of the American Revolution as they wave from their "Caddie."

When the parade reaches Ridge Park there is a ceremony to honor the veterans who have served their country in many wars. There's food, music, and good-old fashioned patriotism.

Art Scheuneman's Belmont Foods was much more than a grocery store. During the early days of integration many rumors swirled around the neighborhood. Belmont Foods was an oasis of information and reasoned thinking where residents could exchange gossip and get an honest assessment of any situation. The successful integration of the community was attributable to both the work of community groups and the efforts of individuals such as Scheuneman. Belmont Foods did not last much longer beyond Art's retirement in 1987, despite the efforts of new owners to keep the business going, and was eventually demolished to make way for town homes.

County Fair Grocery Store held its grand opening on May 9, 1964. Pictured from left to right are architect Bill Benjamin, owner Mr. Bill Baffes, Bill's daughter Terri, Mrs. Joan Baffes holding her son Tom, Alderman Thomas Fitzpatrick, and George Kapsimalis. The Baffes family has owned this staple of Western Avenue providing quality groceries and quality service for almost 40 years. Another new expansion project for the establishment is currently underway.

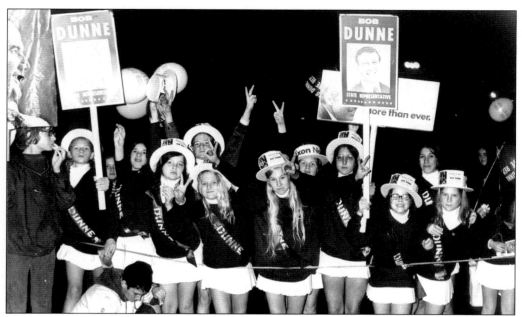

Chicago politics are noted worldwide for feisty campaigns and Machiavellian back-room dealings. Much of the Ridge is part of the 19th Ward, a Democratic Party stronghold that has placed many elected officials in city, county, and statewide offices. The importance of the community's votes is made evident at the Annual Southside Irish Parade on St. Patrick's Day, which often sees politicians of national renown marching down the parade route. This 1970s photo shows a group of young girls demonstrating their support for State Representative candidate Bob Dunne. Signs for presidential candidates Gene McCarthy and Richard Nixon can be seen in the background.

Thomas F. Fitzpatrick, second from right, served four, four-year terms as 19th Ward alderman, from 1957 until 1975, when he retired. Mr. Fitzpatrick was a Democratic Party committeemen and attorney.

For years Arthur Baer, his wife Alice Baer, and Eleanor Pillsbury dreamed of establishing an art center in the Beverly/Morgan park community. Mr. Baer approached the Morgan Park Academy in 1966 when Mr. David Jones was the headmaster. Baer's idea was warmly received and a Beverly Art Center corporation was formed to enter into a fundraising campaign with Morgan Park Academy for the art center and a lower school classroom building. The groundbreaking ceremony for the first art center took place on June 28, 1968. Pictured from left to right are Gustave Orth, James Tuthill, Eleanor Pillsbury, Ross Beatty, Arthur Baer, Alice Baer, and Ruth Elsner.

The laying of the cornerstone of the Art Center took place October 26, 1968. Pictured from left to right are Eleanor Pillsbury, David Jones (headmaster of Morgan Park Academy), Alderman Thomas Fitzpatrick, Arthur Baer, Jerry Bradshaw, Alice Baer, Ruth Elsner, Mrs. Carl Peterson, and the last person is unfortunately not identified. John Hetherington III, a third generation family architect, and grandson of John T. Hetherington, designed the fist Beverly Art Center.

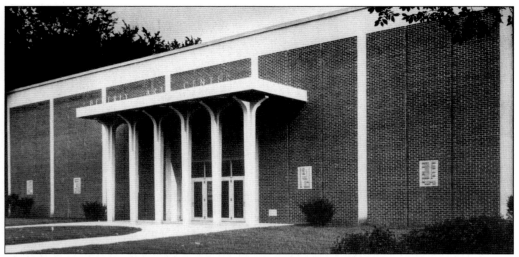

The first Beverly Art Center at 2153 W. 111th Street was completed in 1969. This project was made possible by major gifts from the Baer and Pillsbury families (Charles S. Pillsbury was the Manager of Operations for the Chicago Bridge and Iron Company and a director of the Beverly Bank), and the Vanderpoel Art Association. Mrs. Pillsbury donated $250,000 to help establish the art center. Mrs. Pillsbury and Mrs. Baer wanted a center to house the valuable Vanderpoel Memorial art collection. A new art center opened in 2002 at 111th and Western.

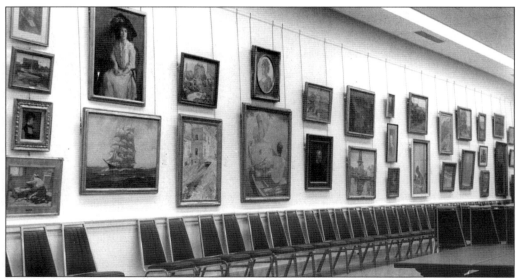

The Vanderpoel Art Association was formed in 1913 with the purchasing of a single Vanderpoel painting funded by the community to memorialize John. H. Vanderpeol, a local resident and accomplished instructor at the Art Institute of Chicago. Many other works by Vanderpoel and other artists were donated to the association by former students and colleagues. Many of the artists' paintings were first displayed at the John H. Vanderpoel School and later in a specially designed gallery at the Ridge Park Field House in 1930. When the art center was completed in 1969, many of those paintings moved to the Vanderpoel Gallery within the center. At the time of this writing, all of the paintings have been moved back to Ridge Park, and the first art center building is operated by the Morgan Park Academy.

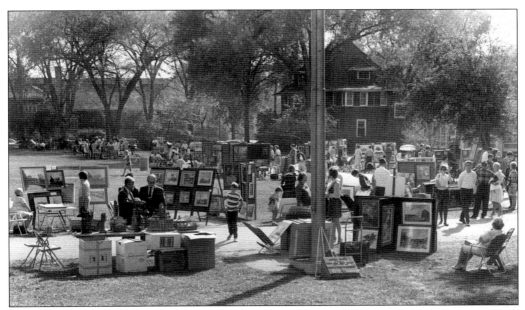

The Beverly Art Center sponsored a number of art fairs on the grounds of the Morgan Park Academy. They featured both local and regional artists, as well as demonstrations of various crafts. A notable item at the fairs was the Guild Hall bread that was baked especially for the event and sold to eager customers.

This unidentified promotional photograph from the collection of the Beverly Bank was just too good to pass up. Nothing is recorded about the young artist or his enthusiastic observer, but they were probably promoting a school program that the bank sponsored.

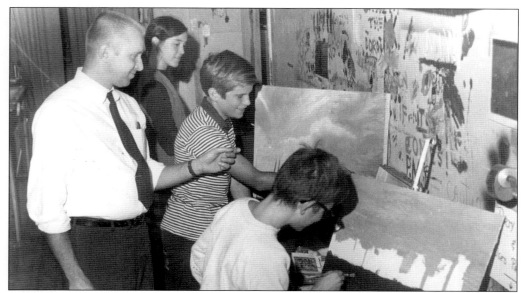

Jack Simmerling opened the Heritage Gallery in 1957. It is currently located 1915 W. 103rd Street. Mr. Simmerling is known for his watercolor and lithographs on the historical aspects of various American cities, especially Chicago. Mr. Simmerling has been commissioned to do work by the City of Chicago, the Chicago Symphony Orchestra, the Vanderbilt's "Biltmore" estate in North Carolina, and the University of Notre Dame. Mr. Simmerling was also a founder of the Ridge Historical Society.

In 1971, an inaugural luncheon was held to discuss the possible founding of an historical society for the Ridge communities. Seated from left to right are Mertice Gawne, Susie Newnam, Jean Barclay, DeWitt Lane, Edna White, Mary Jo Barry, Jeannette Phillips, and Joan Wynne. Standing are Mr. and Mrs. James Merrion, John J. Simmerling, Roger Howe, Eleanor Pillsbury, Margaret Lang, Shirley Haas, and Owen Price.

Seven

PEOPLE OF THE RIDGE

From Thomas Morgan to the Barnards, from Dr. German to Horace Horton, from John Vanderpoel to Mrs. Platt, from Thomas Goodspeed to the Walgreen family, Beverly and Morgan Park have been home to many notable people who have influenced the history of both the Ridge and Chicago. These people have put their own special mark in the history books, and their names are memorialized in buildings and streets throughout the community. Their efforts laid the foundations for the vibrant community that thrives today, and their spirit serves as inspiration to future generations.

Anna Maria Wheeler, who married Thomas Morgan, was reportedly a lady-in-waiting to Queen Victoria of England. When the Queen found out Anna Maria would be accompanying her husband to America, she presented her the root of a red peony from the Royal Garden as a farewell present. Thomas Morgan settled on John Blackstone's property near present-day 92nd Street and Pleasant Avenue, where Anna Maria planted the Queen's peony on what was then a remote prairie. Thomas Morgan was born in England in 1778, and sought his fortune in the diamond mines of South Africa. The Morgan's were, at one time, considered one of the largest land owning families in southern Cook County. There were nine sons and two daughters. William and Charles, Morgan, Thomas's sons, are buried in Mt. Greenwood Cemetery while most of the family rests in Graceland Cemetery. Thomas Morgan died in 1851 and Anna Maria died in 1868.

William Barnard, his brothers Erastus and Daniel, and their sisters Elizabeth and Alice Lucretia were the children of Dr. William Barnard, who came to Chicago in 1846 from Amherst, Massachusetts and settled at what is now 47th Street and Vincennes Avenue. William and Daniel were graduates of Amherst College. William built the first Barnard home on the ridge at 101st and Longwood. Heading west after graduation William ran into Thomas Morgan en route, who convinced him to forego his plans and come to the Ridge as a special tutor to the Morgan children, who he tutored from 1847 to 1850.

Elizabeth Barnard was born in Auburn, Massachusetts in 1823 and came to Chicago with her family in 1846. She moved to what was then known as the Tracy subdivision of Washington Heights in 1871 following the great Chicago Fire. She was one of the founding members of Bethany Union Church in 1872, and died in 1912 at the age of 89.

Alice Lucretia Barnard was the first woman principal in a Chicago public school. She began teaching in a one-room schoolhouse at 12th Street near Wabash, and eventually became principal of Dearborn School in 1871. She would also serve as principal of Jones School, now Jones College Prep School, beginning in 1876. Alice and her brothers Daniel and Erastus bought land in Florida which they developed and where they built winter homes. Born in Templeton, Massachusetts in 1829, she died in 1908. Barnard School is named for this pioneering woman educator.

Erastus Barnard was born in 1833 and settled near 104th and Wood. Erastus married Mary Lavinia Wilcox in 1862, and died in 1915. Erastus donated the land for the 103rd Street Rock Island station for the benefit of the community, and the land for Barnard Park in the memory of their beloved daughter Amy, who died in 1888, at the age of 20.

Sarah Lord Wilcox occupied one of the first homes in the area, the Gardner House, which was originally built as a tavern in 1836 near 99th and Beverly. Her husband purchased the farm that the tavern was located on in 1844, and their daughter, Mary, would marry Erastus Barnard in 1862. Her sister Miranda married William Barnard. The Wilcox family was reinterred in Mt. Greenwood Cemetery after they were moved from a burial site on their farm.

Isaac Blackwelder was Morgan Park's village president for many years, as well as the president of the Calumet Park Board. Mr. Blackwelder was the western manager of the Niagara Fire Insurance Company of New York and was a member of the adjustment board that settled the claims of the Chicago Fire of 1871. He came to Morgan Park in 1886 and rebuilt the Ingersoll House at 10910 S. Prospect. He and his wife relocated to California in 1920 where he died in 1926. Blackwelder Hall in Morgan Park High School and Blackwelder Park, at 115th and Hale, were named in honor of his service to the community.

Dr. William Henry German was Morgan Park's first doctor and the chairman of the 1912 pro-annexation committee. He was born in Greenbush, Canada in 1855. Dr. German set up his private practice in 1884 when Morgan Park was only a small village of 500 people. He was an ardent Methodist and was instrumental in establishing Morgan Park Methodist Church. He also served on the Calumet Park Board and the Morgan Park School Board, as well as the Public Library Board. Dr. German was a company surgeon for the Rock Island Railroad, and died on July 31, 1944

Charles G. Blake was born in Devonshire, England in 1866 and came to America with his family two years later. His father, a monument maker, settled the family in Rhode Island to be near the granite industry. Charles became skilled as a monument designer and in 1887, at the age of 21, was sent to Chicago to manage the western branch of a granite company. He held a seat on the Chicago Stock Exchange from 1893 until 1928. In 1904, he moved to 10835 S. Hoyne and became an active citizen of the community. His greatest passions were art and English lawn bowling (similar to bocce ball). (Photo courtesy of Mount Greenwood Cemetery.)

Mildred Gertrude Ellwood met Charles G. Blake while he was on a business trip. They married and eventually had two sons, Donald, who would carry on the family monument business, and Charles E., who became a writer for the Hearst papers. Mrs. Blake was a founding member of the Morgan Park Woman's Club and an active participant in charity work.

Edna Dickson White was born in 1913 and grew up in Beverly. She graduated from Morgan Park High School in 1931 and DePauw University in 1935. She was an English and physical education teacher in Blue Island and Oak Lawn. In 1955, she married Robert White, a founder and president of the Ridge Historical Society. Edna served on the Morgan Park Council of Human Relations, and the Morgan Park Garden Club. After her tragic death in 1993, organizers of a local garden project renamed it in honor of her compassion and gentle spirit.

Lillian Kistner moved to 10324 S. Prospect with her family in 1887 when she was two and a half years old, and would remain there for the next 35 years. Her father John H. Kistner was active in the community and served on the Washington Heights Village Board and as its water commissioner. In an interview with the Ridge Historical Society in 1976, Lillian recalled well water being better than the water from Lake Michigan that came when Washington Heights was annexed to the city in 1890. She had been a member of Bethany Union Church for 75 years and was also a charter member of the Ridge Historical Society. Miss Kistner died March 9, 1981 at 95 years of age.

Elwood Olson was the grandson of tavern owners John and Hulda Schneider of Washington Heights. Elwood donated a large number of family photographs to the Ridge Historical Society that included numerous pictures of his grandparents' notable establishment.

Hulda and John Schneider operated the Washington House (later Schneider's) Tavern on 102nd Street and Vincennes Avenue. They were part of a large German community that resided in the Washington Heights area near the crossing of the Panhandle and Rock Island Railroads.

Herman Baer was born in East Prussia and was apprenticed as a young boy to a draper. He was abused by his employer and went unpaid for the first year. He served in the German army and left for London after his discharge, learning several trades while he lived there. Growing tired of the rigid class system in England he left for the United States to seek freedom and fortune. He owned his own store before he was 25. This photograph shows him with his wife Frances and son Victor, who died in his teens.

This 1938 photograph shows Arthur Baer, local businessman and president of the Beverly Bank. Arthur was born on Thanksgiving Day in 1886 and would eventually take over his father's department store business. He became a director of the bank in 1929 and served as president and later chairman, beginning in 1944 until his death in 1975. He pioneered the idea of retail banking, a concept that focused on customer service and convenience. Baer and his wife Alice, important leaders in the community, were responsible for the formation or nurturing of a variety of community institutions such as the Beverly Art Center, the Vanderpoel Art Association, the Beverly Area Planning Association, and the Ridge Historical Society.

John Fred Oberg of 11228 Esmond (changed to 11160 Esmond after annexation) was a salesman for the Rice and Hutchins Chicago Company located downtown. He is pictured here with his wife Emma Julia and their children Julian and Jean.

Jean, clamoring around in the buggy, and Julian Oberg are seen is this delightful childhood photograph. Julian would go on to be a department manager for the National Fireproofing Company and Jean became a telegraph operator.

This august group of gentlemen is identified, from left to right, as Major Claxton, pharmacist J.D. Barnes, and photographer Carl Geisler. The photograph, taken around 1909, is in front of Barnes' drug store on the corner of Morgan and Commercial Avenues.

Mrs. Washburn, wife of William W. Washburn, is pictured in this 1874 photograph. Mr. Washburn was the postmaster of Morgan Park and a resident since 1873. Mr. Washburn became the superintendent of the Blue Island Land and Building Company, and the first water system and artesian well were developed under his direction. He built the first commercial building in the village, Washburn Hall, and most of the trees in the village were planted by himself or under his direction. Mrs. Washburn died June 17, 1899, and Mr. Washburn died in 1901.

Ira Price was a professor of theology at Morgan Park Military Academy and along with his brother Enoch J. Price, a local attorney, served as one of the directors of the Calumet Trust and Savings Bank. Ira Price lived at 2124 W. 112th Street. Enoch's son, Owen, was a founding member of the Ridge Historical Society. Owen was born October 13, 1896, attended elementary school at Western Avenue School, high school at Arlington School, and law school at Northwestern University. Owen joined his father's law firm and went on to practice law in Chicago for 42 years. Enoch was the Village Attorney of Morgan Park and fourth president of the Board of Trustees of Morgan Park Academy for 25 years.

Mrs. Harriet Platt and her husband, Dr. Robert Platt, owned the Hopkinson House at 10820 Drew. Although the home already had an interesting history, it was the Platts that really made this home special. The Platts owned the home from 1924 until 1979. Dr. Platt was the Chairman of the Geography Department of the University of Chicago. His wife was once a student of Dr. Platt's and later his research assistant. The Platts had a long history of helping people in need. Over the years, the house was home to foreign exchange students, refugees from the Hungarian Revolution, and Japanese-Americans released to the Platt's from WWII internment camps. Guests of the Platts became known as Plattachés, and have held reunions from time to time over the years.

Eight

MANSIONS AND
BUNGALOWS

With the wealthy elite who resided along the Ridge came their large magnificent homes. Estates sprang up atop the Ridge, and notable architects such as Frank Lloyd Wright, Walter Burley Griffin, Harry Hale Waterman, John and Murray Hetherington, George Washington Maher, and Howard Van Doren Shaw designed distinctive homes here. Victorian, Prairie, Colonial, and Tudor homes are just some of the styles one can find throughout the area. The style and size of the homes quickly set it apart from the rest of the city and helped the area earn the title of "Village in the City." There is even a real castle. Robert Givins built a replica of an Irish castle in 1886 at 103rd and Longwood Drive.

The importance of architectural diversity goes far beyond simple aesthetics and design. This diverse housing stock promotes economic diversity. Many families have lived along the Ridge for generations because one could usually find a house that suited their particular need at a particular time, whether it was a small house starting out or a larger home later on in which to raise a family. This fact, along with the area's convenient access to transportation and good schools has kept many people from moving from the area to find a larger home suitable for a growing income and family. Today, the lack of diverse housing in much of the city is one factor keeping the middle class from moving back to the city. With much of Chicago's single-family housing comprised of bungalows, raised ranches, cape cods, Georgians, and condominiums in downtown/North Side, most neighborhoods in the city do not offer the housing opportunities many families with a household income over $100,000 per year are now looking for.

The architectural diversity along the Ridge is a primary reason why people have stayed in Beverly and Morgan Park. Having a diverse housing stock comprised of Bungalows, medium size homes, and also larger homes fosters economic diversity and the opportunity to move up or down in the housing market without abandoning an area. Many generations of families along the Ridge have been able to stay in the area for that reason, staying close to family and friends, supporting the local schools and churches, and maintaining the bonds that make a community strong. The smaller ranch homes (the next generation of the classic Chicago Bungalow) that were built west of Western after WWII, however, did serve an important housing need for many families in the Beverly/Morgan Park area after the war as well as in the rest of the city, much as the late 19th century workingman's cottage and the bungalow did in the 1920s.

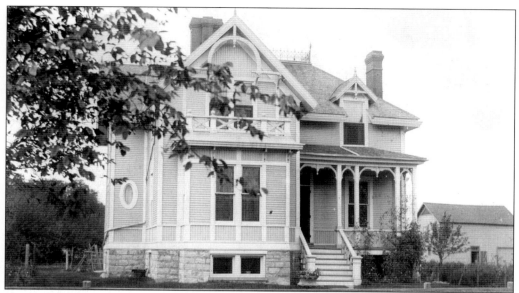

The Barnard House was located at 1924 W. 103rd Street (northeast corner of 103rd and Longwood). It was the home of Alice Lucretia Barnard, her sister Elizabeth, William Wilcox Barnard and his sister Alice Sarah Barnard. Later it was home to the W.W. Barnard Seed Company, which had a magnificent peony farm that stretched back to 101st Street. It became the Tuohey Secretarial School until the name was changed to the Beverly Business College in 1941. After heated opposition by residents who were opposed to a major commercial development at that location, the home was leased by the Jewel Food Company and demolished in 1956 to make way for a grocery store.

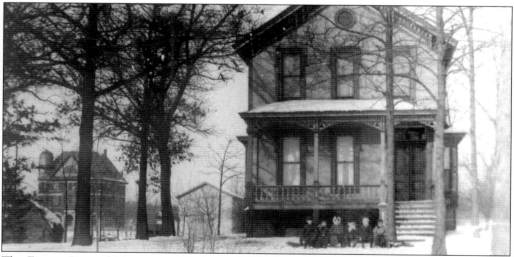

The Erastus Barnard House, seen in this c. 1886 photo, was originally an Italianate-style frame house located at 1808 W. 104th Street. Erastus, and his wife Mary Lavinia Wilcox, owned a farm that extended from 103rd to 107th from Wood Street to about Longwood Drive. According to files at the Ridge Historical Society, this house was moved in 1927 or 1928 to 10444 S. Wood sometime after the death of his wife. The current brick facing was likely added at this time. Tracy Hall can be seen in the left background.

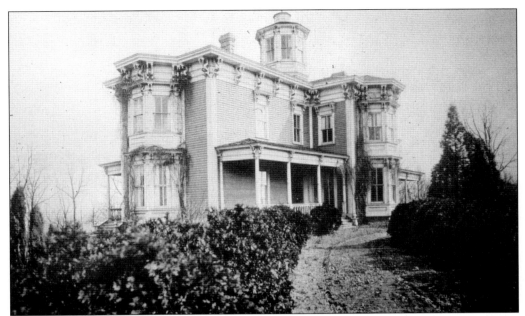

The Clarke House had a commanding view from the top of the ridge near Morgan Avenue (111th Street). Colonel Clarke, a lawyer and one of the founders of Morgan Park, played a significant role in the development and marketing of the Village. He and his wife, Sarah, were devout Christians and avid missionaries, and were responsible for the founding and support of the Pacific Garden Mission.

These homes are examples of some of those built by Charles and Frank Silva. The Silva's were representative of the real estate developers who purchased land from the Blue Island Land and Building Company, improving their lots with newly constructed homes. The following are quotes taken from the firm's promotional booklet: "Morgan Park counts among its residents some of the best businessmen of Chicago, and is blessed with having, generally, the right kind of people... It is not only a temperance Village, but saloons are prohibited by law. Thus, the one curse with which most localities have to contend is here unknown, and our children grow up surrounded only by good influences, while our families can go upon the street, or walk upon our beautiful groves without fear of insult or dread of meeting intoxicated persons."

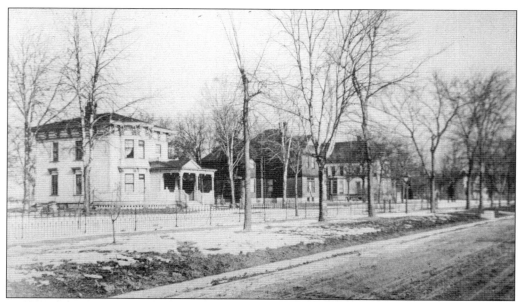

Prospect Avenue was one of the exclusive streets in early Morgan Park, mainly due to its close proximity to the Morgan Park train station. This 1899 photo shows, from left to right, the Ferguson House, the Dr. German House, and the Blackwelder House. These houses face Prospect Park.

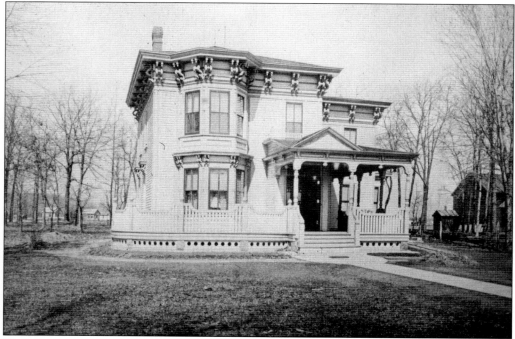

W.G. Ferguson, manager of the Lancaster Fire Insurance Company, built this Italianate-style home located at 10934 Prospect in 1873. It was later owned by Henry Crossman, head of the Nelson Morris Packing Company and one of the founders of the Chicago Opera Company.

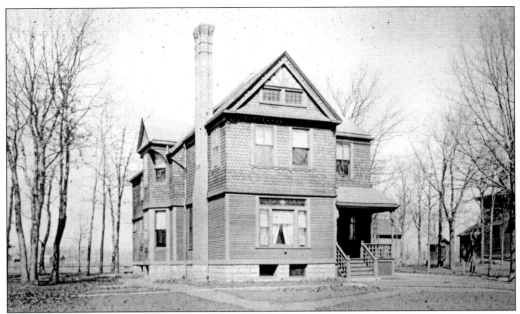

This Queen Anne style home at 10924 Prospect was built by Dr. William German in 1884. German was Morgan Park's first doctor. This photograph was taken in 1899.

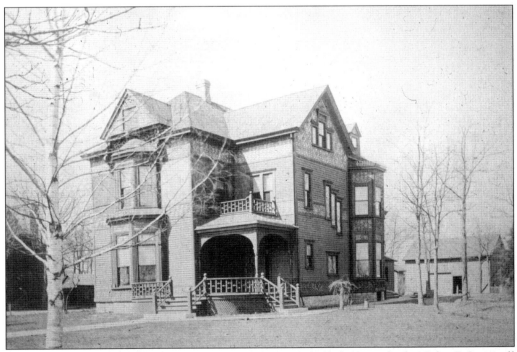

The Ingersoll-Blackwelder House at 10910 Prospect was built for grain broker John E. Ingersoll in 1874. The Queen Anne front was added in 1887 by Morgan Park Village president Isaac Blackwelder. In August 1913, his wife, Gertrude, was the first woman to vote in a local election. He served on the high school board of education for many years.

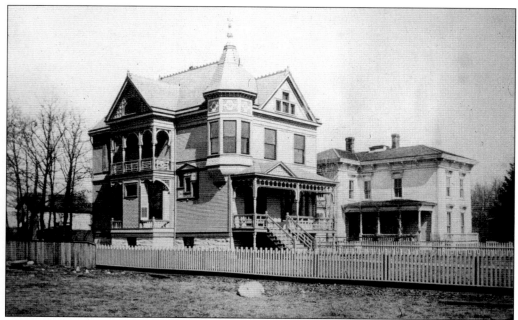

The Queen Anne style Bohn House at 10980 Prospect, as it looked in 1899, was the home of Henry J. Bohn, a village trustee, president of the Calumet Park District, and owner of *Hotel World* magazine. Bohn Park at 111th and Longwood was named after him, and was originally used as a place for Baptist concerts.

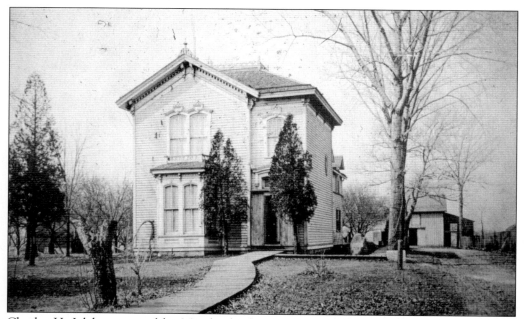

Charles H. Iglehart, a wealthy Maryland tobacco farmer, built this Italianate-style home at 11118 Artesian in 1857. The family lived in the home until 1922. The house was moved back 30 feet in 1923 from its original location to make room for the widening of Western Avenue. It is the oldest home in the community, and a city landmark.

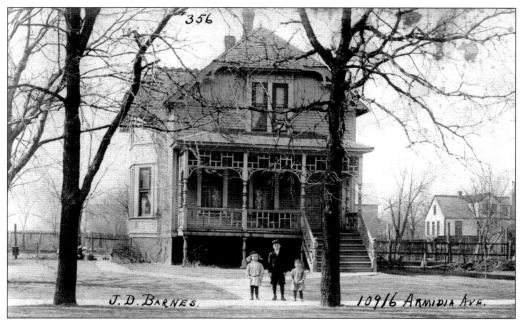

In 1909, C.L. Groesbeck photographed virtually every building in Morgan Park. These images were reproduced as postcards and made available for sale. Many of the homeowners and their families posed in front of the homes, such as pharmacist J.D. Barnes' children, then at 10916 S. Armida.

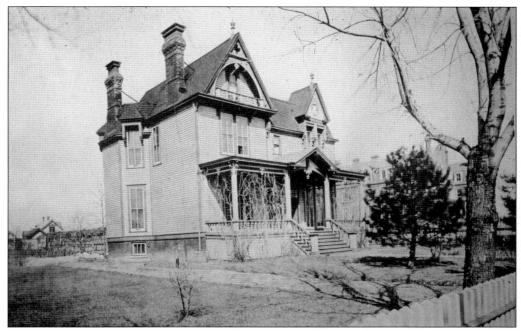

Dr. George W. Northrup of the Baptist Theological Seminary and his wife lived in this home at 2242 Morgan Avenue. Dr. Northrup was a professor of systematic theology and the first president of the seminary.

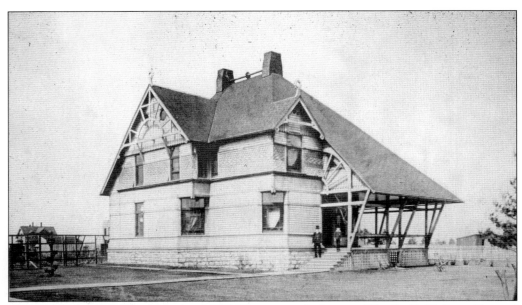

The odd-looking Hulbert House at 10938 Hoyne was the home of Dr. Eri B. Hulbert, Dean of the Chicago Baptist Theological Seminary in Morgan Park. Dr. Hulbert was also professor of church history, church polcy, and pastoral duties.

Judge Lemuel T. Goe was a Kentucky gentleman and served as police magistrate and Justice of the Peace of Morgan Park for over 40 years, dying in office in 1907. This is a photograph of his home located at 1622 Morgan Avenue (Monterey).

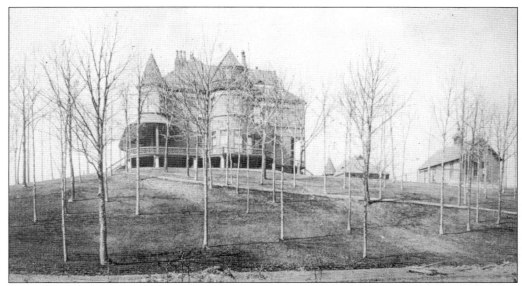

The Silberhorn House, a Queen Anne style home located at 11246 Longwood, was built in 1886 for William H. Silberhorn. The W.H. Silberhorn Packing Company was located at 45th and Packers Avenue (location of the former Chicago Union Stockyards). Silberhorn resided in this home until his business collapsed in 1898. He relocated to Colorado where he engaged in a mining business until his death in 1915. The home was subsequently owned by William Schulze, owner of the Schulze Baking Company.

Edward Ayers was the village clerk of Morgan Park. Pictured in the photograph are Vivian Saunders, Mary Smith, and Edward's children Ellen and Alma. The wooden sidewalk is a notable characteristic of the photograph. Wooden sidewalks were common throughout the community at the time. Silva Hall can be seen in the right background. The photograph was taken in front of the home at 2051 Park Street (Pryor Avenue) in 1894.

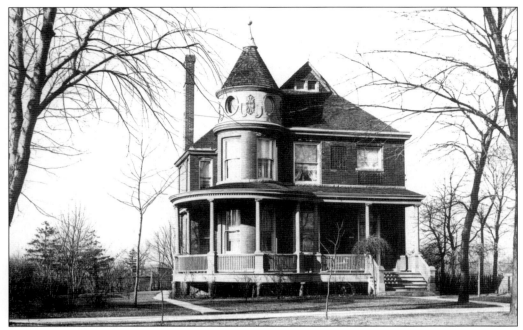

This Queen Anne style house at 11314 Lothair was the first brick house built in Morgan Park. It was constructed for Hugh Riddle, a vice president of the Rock Island, as a "summer" residence, and subsequently was occupied by the Dangremond family from 1908 until 1980.

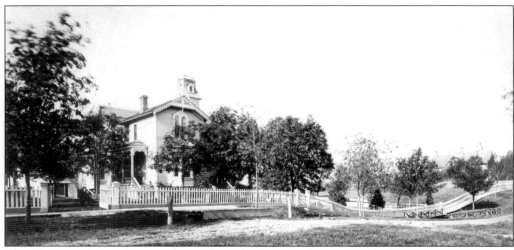

The J.B. Chambers House at 10330 S. Seeley was built in 1874 and has characteristics of Italianate, Gothic, and French Empire designs. Chambers, a real estate promoter, and Charles F. Springer of 10302 Seeley subdivided the area south of 103rd Street. This was the original location of the Ridge Country Club until it moved to 105th and California. Demand for land in the immediate area was high. This move allowed this marketable area to be platted and developed into homes. The east side of Hoyne Avenue west to Leavitt, between 103rd and 105th was developed by Ridge Homes, a development company, sometime after Ridge Country Club relocated in 1916. One of the developer's offices was located at 10301 S. Hoyne Avenue. This house is still standing.

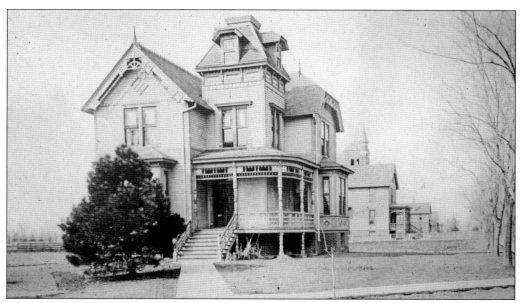

Donald C. McKinnon was a Morgan Park Justice of the Peace, a village collector, and was also involved in the real estate and insurance businesses. His home, which is no longer standing, was located at 11104 S. Hoyne. The home pictured behind the McKinnon house, which is still standing, and Blake Hall of Morgan Park Military Academy can be seen in the background. Blake Hall was destroyed by fire in 1962. This photograph was taken in 1889.

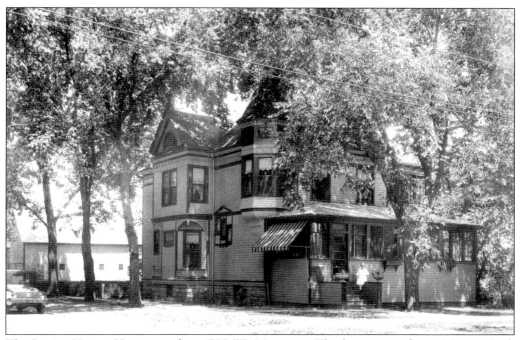

The Louise Virene House stood at 1728 W. Monterey. The house served as a Morgan Park cafeteria. It was built in 1891 and demolished in 1975. Mrs. Virene is sitting on the steps in this photograph taken about 1932.

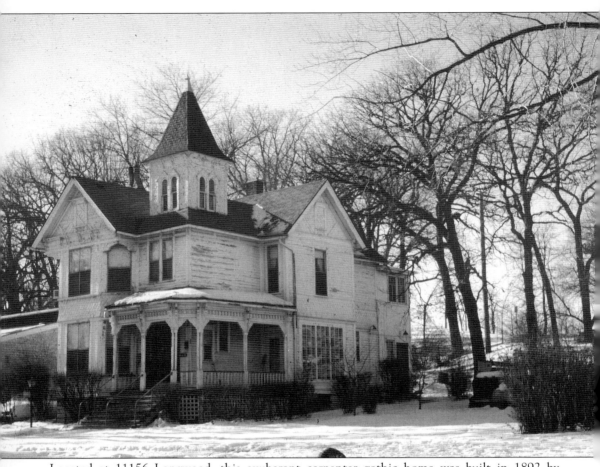

Located at 11156 Longwood, this exuberant carpenter gothic home was built in 1892 by Herman Beurdorf. It was sold to Sarah Clarke in 1894. She transferred it to the Pacific Garden Mission, which was started by her and her husband, George. It was rented, for a time, by Phillip W. Yarrow, the minister of the Morgan Park Congregational Church, who later purchased it.

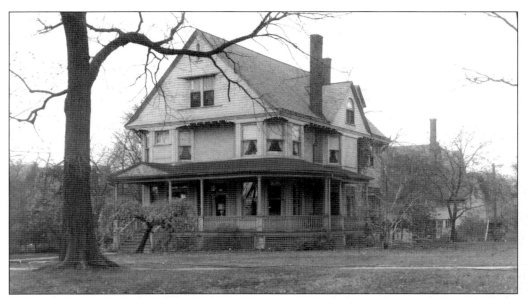

The Ira Price Home at 2124 W. 112th is a Queen Anne style home that was built in 1893 for Ira Price, a professor of theology who had his own illuminating gas plant. The home was wired for electricity 10 years before electricity was available there. The home was designed by architect William J. Vankeuren.

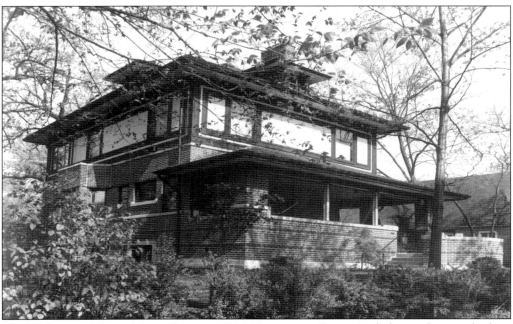

The William and Jesse Adams House at 9326 Pleasant is a Prairie Style home that was built in 1901 and designed by Frank Lloyd Wright. William Adams was the contractor for two earlier designs by Wright. Walter Burley Griffin Place (104th Place between Prospect and Wood) is named after Griffin, who was Frank Lloyd Wright's contemporary. The neighborhood of Walter Burley Griffin Place contains the highest concentration of his Prairie Style houses in the country.

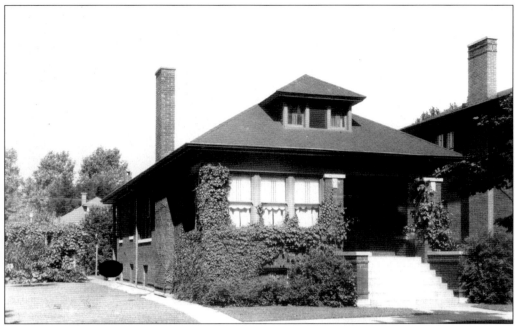

Thousands of Chicago Bungalows were built in the 1920s and 1930s to meet Chicago's burgeoning housing demand. The classic bungalows were practical, affordable, and played a significant role in the development of Chicago. The Raised Ranch homes built after WWII were second-generation bungalow design, yet lacked the decorative woodwork and many built-in features of their predecessors. There are approximately 80,000-100,000 bungalows in Chicago such as this one located at 9606 S. Damen.

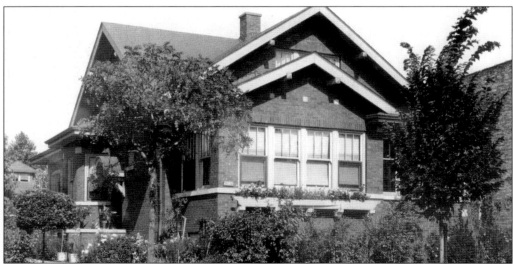

Though simple in design, the bungalow offered adaptability and expandability to a solidly built working-man's one-and-a-half story home as illustrated in this modified bungalow at 9540 S. Damen. Mayor Daley announced the Chicago Bungalow Initiative in front of a Beverly bungalow. The program is aimed at preserving a classic example of Chicago architecture and history by offering incentives for the purchase, restoration, and maintenance of a Chicago icon.

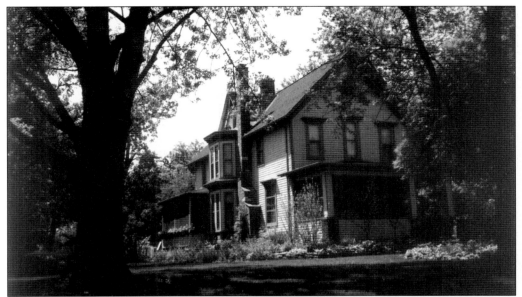

The Italianate Thomas W. Goodspeed House at 11216 S. Oakley was built in the 1870s. It was from this home that Goodspeed organized the Morgan Park Baptist Church in 1877 and later conducted the correspondence that would convince John D. Rockefeller to donate $35 million needed to found the new University of Chicago in Hyde Park allowing Dr. William Rainey Harper to become the school's first president. (Author's photograph.)

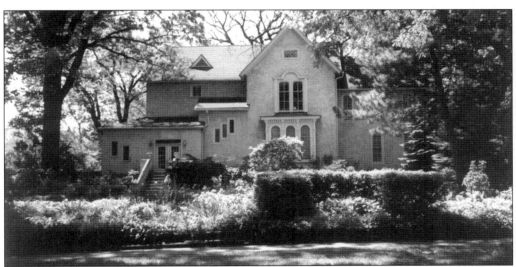

The Italianate Hopkinson-Platt House at 10820 S. Drew was built in 1871 by William Hopkinson, a local real estate dealer for the Blue Island Land and Building Company and first president of the Village of Morgan Park. Hopkinson was born in England on July 10, 1834. The home sits on what was reportedly once Indian council grounds. The home was reputedly built as an English country house with wandering sheep and cows for Hopkinson's wife, Jane, whom he married in 1855 and who did not want to leave England for a log cabin in another country. The original front of the house faced south toward Prospect, and the original structure has since been covered with stucco. (Author's photograph.)

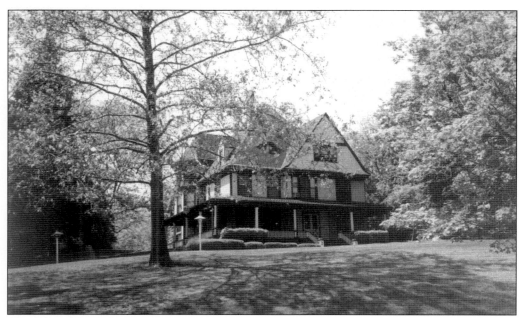

The Edward L. Roberts House at 10134 S. Longwood is a Queen Anne style home that was built in 1893 by a lumber milling magnate as a showcase of examples of the woodwork he sold. The house sits near the site of the first William Barnard home. It was purchased by St. Barnabas Church in 1924 and has been used as the church rectory since 1947. (Author's photograph.)

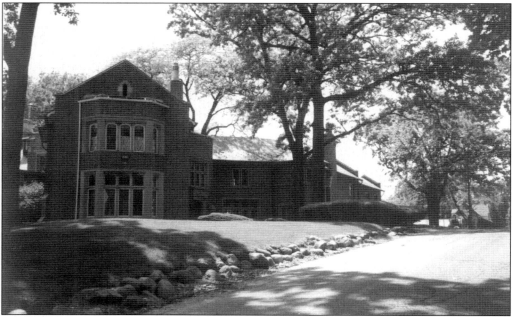

This Tudor Revival home at 116th and Longwood was designed by Harry Hale Waterman and built for the Barker family in 1925. It was later owned by the Charles R. Walgreen family, founder of Walgreen Drugstores, until the 1950s when it was given to the Sisters of Mercy as a retreat house, the Cenacle. It is now a facility for Mercy Home. (Author's photograph.)

The William M.R. French House at 9203 S. Pleasant is an 1894 Colonial Revival style home that was built by the first director of the Art Institute of Chicago, landscape architect William M.R. French, after the institute was incorporated on May 24 1879. Mr. French's wife, Alice Helm French, reportedly suggested "Beverly" as the name for the 91st Street Rock Island station after her childhood home in Massachusetts. This legend is still disputed, but the name stuck, and years later, the Rock Island was petitioned by local businessmen to change the name of all the "suburban" stations from 91st Street to 103rd Street to "Beverly Hills," thus unifying the Ridge area as one community. The home was designed by architect William Augustus Otis. (Author's photograph.)

The John H. Vanderpoel Home is located at 9319 S. Pleasant Avenue and was owned by John Vanderpoel, a well-known artist and protégé of William M.R. French. Mr. Vanderpoel taught figure drawing at the School of the Art Institute for 30 years, and was the author of *The Human Figure*, first published in 1957 and still in print. (Author's photograph.)

Casa Del Loma Apartments at 11057 S. Hoyne was originally the library for the Baptist Union Theological Seminary until it was moved across the street and remodeled into Spanish Colonial style apartments and a tea room after serving as the Parish House for the Church of the Mediator. (Author's photograph.)

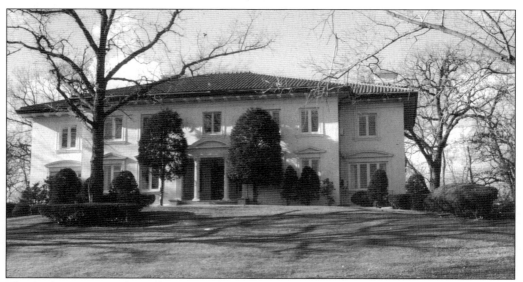

The Anderson House, located at 10400 S. Longwood Drive, was designed by Oscar L. McMurry in the Renaissance Revival style and was built for Frank M. Anderson, owner of the Sall Mountain Asbestos Manufacturing Company in 1924. The Andersons owned the home from the 1920s until 1953. It was subsequently owned by John S. McKinlay, president of Marshall Fields and chairman of the board of the National Tea Company. This home has been the official residence of the president of Chicago State University since 1971. (Author's photograph.)

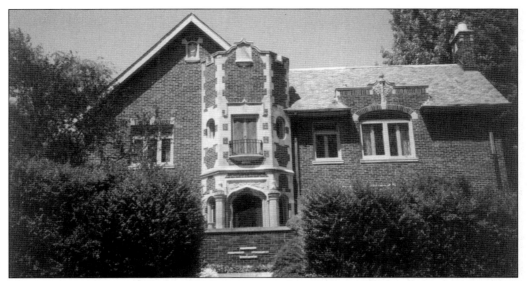

The Wm. H. McDonnel House at 10162 S. Longwood is a Tudor style home that was built in 1929 and was designed by Homer G. Sailor. The home was built for the founder of the *Southtown Economist* newspaper, William McDonnel, whose firm bought the *Englewood Economist* and *Merchants' Telegram* in 1918. In 1923, McDonnel merged the two into the *Southtown Economist*. (Author's photograph.)

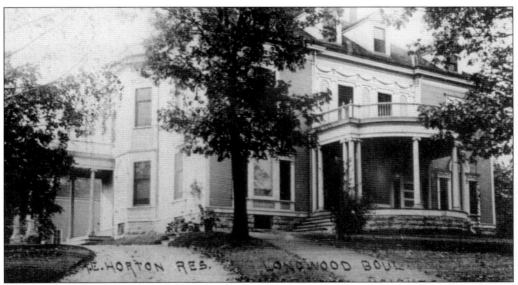

The Horton House at 10200 Longwood was built in 1890. It is a Colonial Revival style home designed by John T. Long. Horace E. Horton was the founder of the Chicago Bridge and Iron Company. His factory was located on Vincennes Avenue between 105th and 107th Streets. Horton was also a principal founder of Beverly Bank. Originally, there was a porte-cochere on the south side (left) of the home, which was removed and was used as a carriage pick up and drop off point. The home was designed with a full-scale ballroom on the third floor. The Horton House, like many of the larger homes in Beverly, was originally located on a large parcel of land. Over the years, the land from these various estates was subdivided to make room for other homes.

The home pictured on the left in this photograph of 103rd and Longwood Drive, was built in 1908 for civil engineer George T. Horton, son of Horace E. Horton. The porte-cochere on the left (south) side of Horace Horton's home can be seen in the background. This view is facing north down Longwood Drive in the 1920s. The Givins Castle cannot be seen in this photograph, but it is located out of view on the left of this photograph.

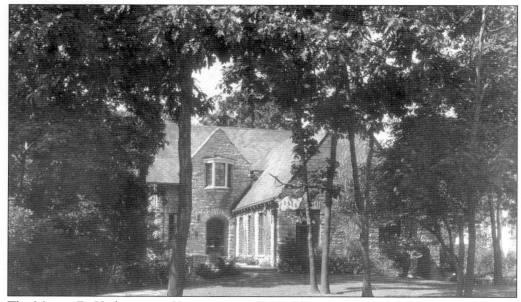

The Murray D. Hetherington House at 8918 S. Hamilton is a Tudor home that was designed by and built for prominent local architect Murray Hetherington in 1924. Three generations of Hetheringtons designed many buildings in the area, including the Ridge Park field house and the Driscoll House.

The Driscoll House, located at 10621 S. Seeley, was designed by John T. Hetherington in 1922. This Tudor style house was donated to the Ridge Historical Society in 1971 by James Driscoll, a local electrical contractor. The Society's mission is to preserve and interpret the history of Beverly Hills, Morgan Park, and Washington Heights, collectively known as the Ridge communities. An earlier Morgan Park Historical Society operated for decades, but ceased to exist in the 1930s. In the intervening years a number of individuals would continue to collect information; in particular, Alberta Killie, the librarian at the Walker Branch Library. Also instrumental in keeping the community's history were Robert White, Owen Price, Gary Sauerman, Fran Warren, and the Lane family.

Bibliography

Andreas, A.T. *History of Cook County*. Chicago: A.T. Andreas, 1884.

Archdiocese of Chicago. A *History of the Parishes*. Chicago, 1980.

Brandon, Fred K. and Alice Howe. *Bethany Union Church, A History*. Chicago: Bethany Union Church, 1972.

Chicago Fact Book Consortium. *Local Community Fact Book: Beverly Hills*. Department of Sociology, University of Illinois at Chicago. Chicago: 1980.

Hirsch, Arnold R. *Making The Second Ghetto: Race & Housing in Chicago, 1940-1960*. New York: Cambridge University Press, 1983.

Lemann, Nicholas. *The Promised Land: The Great Black Migration And How It Changed America*. New York: Alfred A. Knopf, 1991.

Mayer, Harold and Richard Wade. *Chicago, Growth of a Metropolis. Chicago:* University of Chicago Press, 1969.

Pacyga, Dominic. "Beverly/Morgan Park." *Chicago Journal* 24 Mar. 1985: p. 1.

Pacyga Dominic and Charles Shanabrunch. *The Chicago Bungalow*. Chicago: Arcadia Publishing, 2003.

Pacyga, Dominic and Ellen Skerrett. *Chicago, City of Neighborhoods*. Chicago: Loyola University Press, 1986.

Ridge Historical Society: Clippings Files

Roth, Leland. *McKim, Meade, and White Architecture*. New York: Harper and Roe Publishing: 1983.

Shanabrunch, Charles. *Chicago's Catholics*. South Bend: University of Notre Dame Press, 1981.

McCafferty Lawrence J., Ellen Skerrett, Micheal F. Funchion, and Charles Fanning. *The Irish in Chicago*. Urbana: University of Illinois Press, 1987.

Squires, Gregory, with Larry Bennet, Kathleen McCourt, and Philip Nyden. *Chicago: Race, Class, and The Response To Urban Decline*. Philadelphia: Temple University Press, 1987.

Volp, John H. *Blue Island: The First Hundred Years*. Blue Island: The Blue Island Historical Review, 1935.

Wolf, Wayne and Jack Simmerling. *Chicago's Old Houses, Lore and Legend*. New York: McGraw-Hill, 1997.